MW00605527

IMAGES
of America

WATAUGA COUNTY
REVISITED

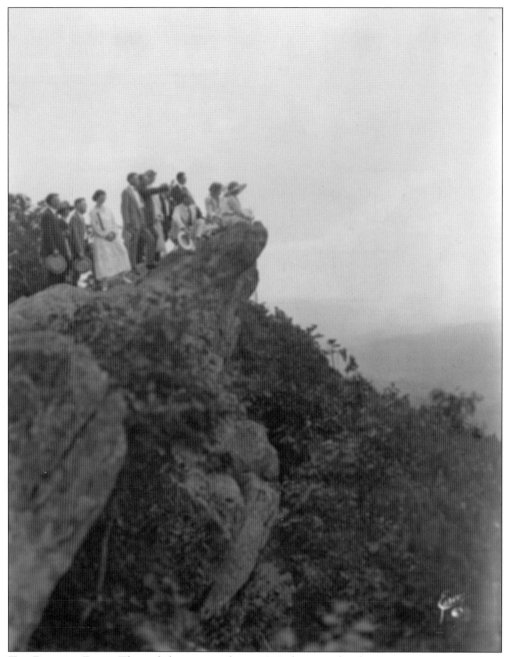

The Blowing Rock. The stylish group in this c. 1919 photograph takes in mountain vistas from atop the now-famous rock formation. (Courtesy of the North Carolina Collection, University of North Carolina Library at Chapel Hill.)

On the Cover: Road Trip. These Cove Creek residents enjoy a road trip to Lenoir in the 1910s, when cars were rare and roads were rudimentary. The suitcase on the side of the car probably indicates an extended stay. From left to right are Addie Horton Mast; her mother, Polly Councill Horton; her son Tom Mast; and her father, Jim Horton. (Courtesy of James B. Mast Jr.)

IMAGES
of America

WATAUGA COUNTY
REVISITED

Terry L. Harmon

ARCADIA
PUBLISHING

Copyright © 2016 by Terry L. Harmon
ISBN 978-1-4671-3439-2

Published by Arcadia Publishing
Charleston, South Carolina

Printed in the United States of America

Library of Congress Control Number: 2015937085

For all general information, please contact Arcadia Publishing:
Telephone 843-853-2070
Fax 843-853-0044
E-mail sales@arcadiapublishing.com
For customer service and orders:
Toll-Free 1-888-313-2665

Visit us on the Internet at www.arcadiapublishing.com

This volume is dedicated to my uncle Jackson W. Henson, who helped inspire in me a love for history and its preservation.

CONTENTS

Acknowledgments 6

Introduction 7

1. Agriculture, Commerce, and Industry 9

2. Schools and Religious Life 39

3. Home, Family, and Leisure 53

4. Oh, Play Me That Mountain Music! 77

5. Mountain Fashion 85

6. Natives and Other Notables 93

7. Mother Nature 105

8. Everyone Loves a Parade! 107

9. Around the Appalachian State University Campus 113

10. Local Landmarks 119

ACKNOWLEDGMENTS

I would like to offer my sincere appreciation to the many generous individuals, groups, and institutions whose photographic contributions made this work possible: Bob Barnhardt, Ben Blackburn, Sandra Blankenship, David Gaynes, Nannie Greene, Hilda Greer, David Harmon, Jack Henson, David Holt, Larry Klutz, Ralph Lentz, Ben Mast, Gladys Mast, James B. Mast Jr., Tony Matheson, Eude Moody, William Reese, Sarah Spencer, Margaret Trivette, the Warner family (Jeff and Gerret), Diana Mast White, Appalachian State University, Bobby Brendell Postcard Collection, Historic Boone Collection, Junaluska Heritage Association, Library of Congress, NC Digital Heritage, Raleigh *News & Observer*, Sourisseau Academy for State and Local History at San Jose State University, North Carolina State University, the Cy Crumley Scrapbook, the State Archives of North Carolina, University of North Carolina at Chapel Hill, Watauga County Historical Society, and Watauga County Public Library.

Thanks go to the following: Matt Wagoner; Henry Clougherty of Arcadia Publishing; Greta Browning and Leah McManus of Appalachian State University; Cathy Dorin-Black, Jennifer Baker, and William Cross of North Carolina State University; Keith Longiotti of the University of North Carolina at Chapel Hill; William Brown, Kim Andersen, Sarah Koonts, Ian Dunn, and Matthew Waehner of the State Archives of North Carolina; Scott Sharpe of the *News & Observer*; Leilani Marshall of the Sourisseau Academy for State and Local History at San Jose State University; and Maria Hale and Ross Cooper of the Watauga County Public Library and Eric Plaag for their assistance in navigating collections, processes, and permissions.

Although already acknowledged, I want to give special recognition to my cousin James B. "Jim" Mast Jr., whose collection of old photographs I have relied heavily upon. On more than one occasion, he and his gracious wife, Maxine, allowed me to visit their home and "mine for gold." Because of Mr. Jim's generosity and his family's foresight in preserving their photographs, I am able to share many never-before-published images from our county and from western Watauga in particular.

While pursuing genealogical endeavors over the past almost 40 years, I have amassed quite a personal collection of photographs. Unless otherwise noted, all images appear courtesy of the author.

Finally, thanks to you, the readers, for your interest in our history and for taking time to revisit Watauga County!

INTRODUCTION

This volume is exactly what the title states: a revisiting of Watauga County. Much has been written and rewritten about this county, which raises the question, "How much more can be said?" But, for lovers of history such as myself, there is always more to be uncovered. Some revisits yield the same results. But, every now and again, a reconsideration enables one to see a familiar subject from a different vantage point. That is my hope for this book. While covering some of the same general themes and categories addressed by other authors, I have attempted to introduce new material without duplicating photographs from past publications. While challenging, I believe I have, with perhaps a few exceptions, succeeded.

This work is not intended to be a history or comprehensive study of Watauga County. It would be impossible to capture 166 years within the limitations of this volume. Even more extensive works would be hard pressed to cover all that has transpired since the county was established in 1849. Admittedly, this work is not even as representative of the entire county as it could be. I am an eighth-generation Wataugan; many of my ancestors arrived here in the 1790s, almost 60 years before the county existed. But I am also primarily a western Wataugan, mostly rooted in the communities and townships west of the county seat of Boone. So, the reader will discover that many of these photographs are from "the west." This is not an intentional slight to other parts of the county, but merely a reflection of the materials to which I have had the most access. Still, the county is historically very homogenous and the communities very interconnected, both from a cultural and a socioeconomic viewpoint, and quite often by intermarriage and blood. My hope is that, as you view these images and read the associated captions, it will be understood that what is depicted for one particular location can be extrapolated to the greater county population as shared experiences.

While this is not a history of Watauga County, I would be remiss not to include at least a cursory review of its background and beginnings, particularly for those who may know little of this area or for whom this book is their introduction to the county's past.

Long before this was a county, before its mostly white forefathers ventured to this land, it was inhabited by the Cherokee Indians. They held the whole mountain region of the south Alleghenies in southwestern Virginia, western North Carolina and South Carolina, northern Georgia, east Tennessee, and northeast Alabama, and claimed land even to the Ohio River. Although archaeological digs and even the simple discovery of arrowheads in a plowed field have proven that Indians camped and hunted in this area, there is no record that white men ever came into contact with them in what is now Watauga County.

The first documented white visitors in present-day Watauga County were Bishop August Gottlieb Spangenburg and his party, who traveled from Pennsylvania to North Carolina in 1752 to locate lands for a Moravian settlement. The party crossed the Blue Ridge Mountains at Coffey's Gap near present-day Blowing Rock and descended the South Fork of the New River to Three Forks and beyond. In his journal, Bishop Spangenburg made no mention of encountering Indians. He

wrote that the area would be an ideal location for a colony to undertake missionary work among the Indians, although none lived there. It is believed that Ashe County, which encompassed much of present-day Watauga, was partially settled by white people, principally hunters, as early as 1755. But, again, there is no record of encounters between those settlers and Indians. Daniel Boone did not encounter them during his first trip through this area to Kentucky in 1769, nor did James Robertson on his first trip to the Watauga Settlement in Tennessee that same year.

By the mid-1700s, many whites had arrived in the Piedmont region of the state, particularly in places like Rowan County, which was an important post along the Great Wagon Road from Pennsylvania, through Maryland and the Shenandoah Valley of Virginia, into North Carolina. Most people sojourning southward were of English, German, Scottish, and Irish ethnicity. By the late 1760s and early 1770s, many North Carolinians of the Piedmont were becoming disenchanted with British provincial rule and, intrigued by the stories of land west of the Appalachian Mountains, began to consider relocating there, despite an earlier proclamation by British authorities forbidding encroachment into Native American territory. This hastened the forays of early frontiersmen like Robertson and Boone into east Tennessee and Kentucky. The subsequent Battle of Alamance in 1771 and the failure of the Regulator Movement further encouraged Piedmont settlers to venture west.

The 1770s witnessed several treaties between the Cherokees and whites, and the establishment of the Watauga Settlement in east Tennessee was instrumental in many of those relationships and developments. The Treaty of Sycamore Shoals was negotiated on March 19, 1775, (one month before the outbreak of the American Revolution) at Sycamore Shoals (now Elizabethton, Tennessee) on the Watauga River. As part of these negotiations, the Wataugans bought their land and named their country the Washington District. This area included present-day Watauga, Ashe, and Alleghany Counties. In 1777, the Washington District, which had been named by the Watauga Association, became Washington County, North Carolina, and in 1778, the Watauga Association ceased to exist. Present-day Watauga County was within the boundaries of Wilkes County between 1792 and 1799 and then Ashe County from 1799 to 1849, when the county was formed.

Jordan Councill Jr. was instrumental in getting Watauga County established. His brother-in-law George Bower served in both houses of the North Carolina state legislature, and as the movement to establish Watauga County reached its head in 1848, Bower was the North Carolina state senator from Ashe County. Councill, being the primary, if not only, merchant at the time in what was later to become Boone, had great influence in political matters. In addition, being married to Bower's sister gave him a unique opportunity to be heard. As a result, a bill for a new county was introduced in the legislature and passed by the general assembly on January 27, 1849. Watauga County was formed from parts of Ashe, Caldwell, Wilkes, and Yancey Counties, but primarily from Ashe. In 1872, the Town of Boone was established as the county seat and named for frontiersman Daniel Boone, who traversed, camped, and hunted here at various times.

With this short history in place, let us now take a photographic look at the life—homes, work, dress, traditions, education, religion, music, and leisure—of Wataugans, particularly from the late 19th century into the early 20th century.

One

AGRICULTURE, COMMERCE, AND INDUSTRY

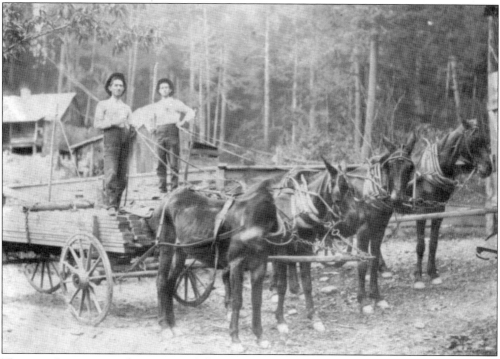

HAULING LUMBER. Brothers Oscar Phillips (1879–1951, left) and Amos Phillips (1874–1949) of Phillips Branch near Sugar Grove utilize team-drawn wagons to haul lumber in this c. 1900 photograph. (Courtesy of Hilda Greer.)

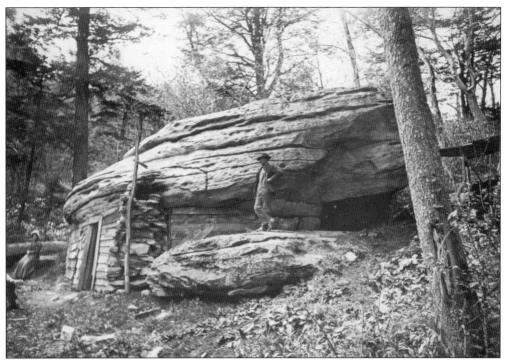

Cave-Dwelling Galaxers. Galax-gathering mountaineers are shown outside of their modified cave home on Yonahlossee Road in Blowing Rock around 1912. (Courtesy of the State Archives of North Carolina.)

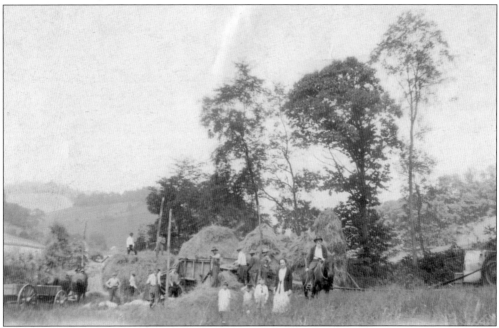

Stacking Hay. Men stack hay on the Vanderpool farm of Jim Horton in the 1920s. Horton is seen astride a horse beside his daughter-in-law Sadie Splitstone Horton and her children (from left to right) Mary Jeannette, Dick Jr., and Howard Horton, who were visiting from Farrell, Pennsylvania.

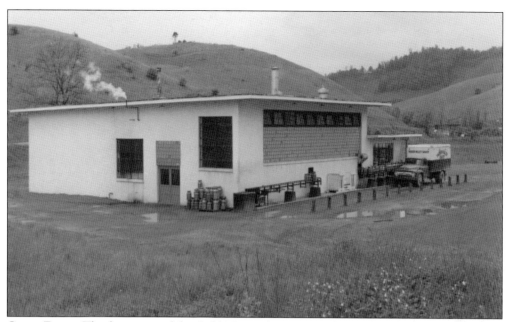

Coble Dairy. The formation of the Coble Dairy at Cove Creek provided additional income for farmers who collected and transported milk to the dairy. Seen here in 1958 is the second Coble Dairy on George's Gap Road near Old US Highway 421. This building replaced a smaller dairy that stood adjacent to this site. (Courtesy of Special Collections Research Center, North Carolina State University Libraries, Raleigh, North Carolina, UA100_099.)

Burley Tobacco. In 1919, only four acres were devoted to tobacco production in all of Watauga County. By 1924, that figure had doubled to eight acres. In 1929, 54 farms reported growing it. Burley tobacco became a cash crop in the 1930s and 1940s. By 1969, 777 farms grew it. Seen here in his "patch" in the 1950s is Ben Thompson (1875–1960) of Cove Creek. (Courtesy of Gladys Mast.)

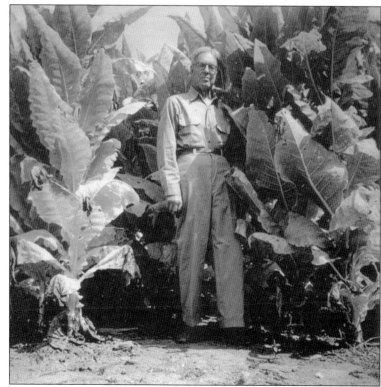

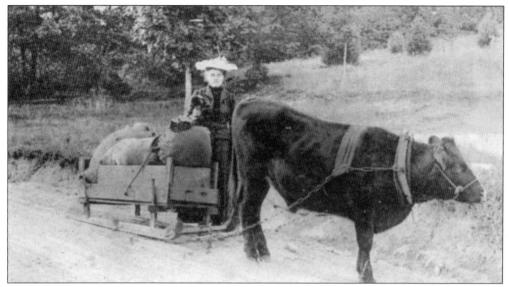

MARKETING GALAX. This young woman in Blowing Rock is dressed up to take galax to market via a cattle-drawn sled. Galax was among the plants gathered during "wildcrafting," the practice of harvesting plants from their wild habitat for food or medicinal purposes. Galax was used in herbal medicine to treat cuts and kidney ailments. (Courtesy of the Bobby Brendell Postcard Collection, Watauga County Historical Society, and the Digital Watauga Project.)

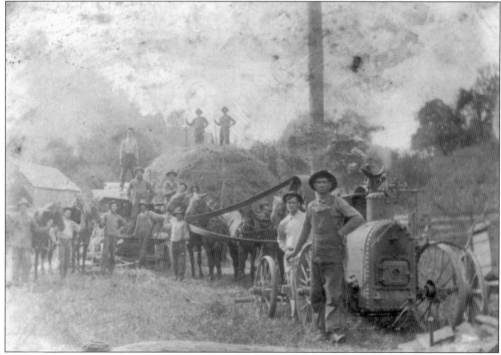

STEAM THRESHER. This photograph, likely taken between 1900 and 1910, shows men working in a field with a steam-operated thresher. Note the large stack of hay in the background. The setting is most likely Cove Creek Township. The only identifiable men are Charles Henson (foreground, right) and, possibly, his brother Watt Henson (left of center, hands on hips).

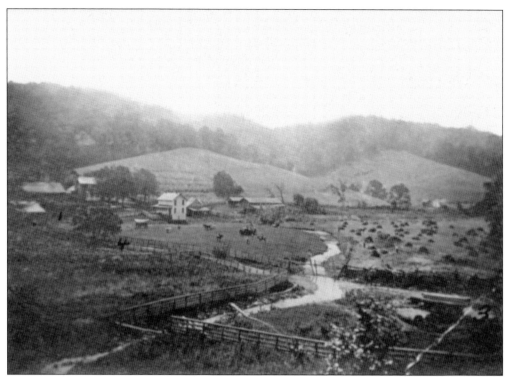

COUNCILL FARM. This is believed to be the farm of Benjamin Councill. Formerly located in present-day Vilas, probably in proximity to the old Vilas Grocery, Vilas Post Office, and the intersection of US Highways 421 and 194, this elaborate farm had homes and extensive outbuildings, pastures, and fence works. Note the covered wagon left of the white farmhouse. (Courtesy of James B. Mast Jr.)

A GOOD TEAM. Practically every farmer required the use of a good team (typically horses) for plowing and other forms of work. Here, William Hardy Mast (1875–1947) of Sugar Grove in Cove Creek Township stands with his team, Maude and Nell. (Courtesy of Gladys Mast.)

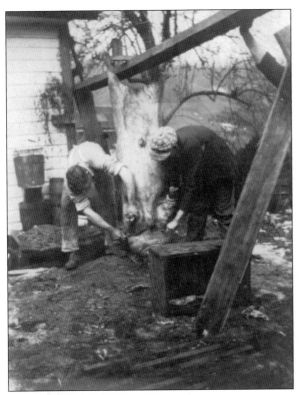

HOG KILLING. Pork was a staple of most early Wataugans' diets, and the traditional "hog killin' time" was between Thanksgiving and Christmas, when the weather turned cooler, particularly in the days before refrigeration became common. Here, men slaughter a hog near the home and store of Newton L. "Newt" Mast at Mast in Cove Creek Township in the 1920s. (Courtesy of James B. Mast Jr.)

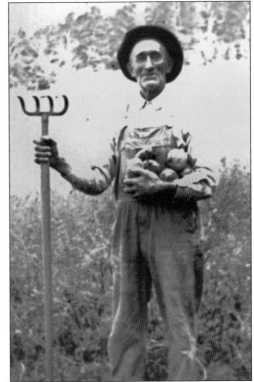

POTATO HARVEST. "Taters" have been a staple of the mountain diet for generations. Here, local veterinarian George Hamilton Hayes of Vilas shows off an armful of potatoes he has harvested.

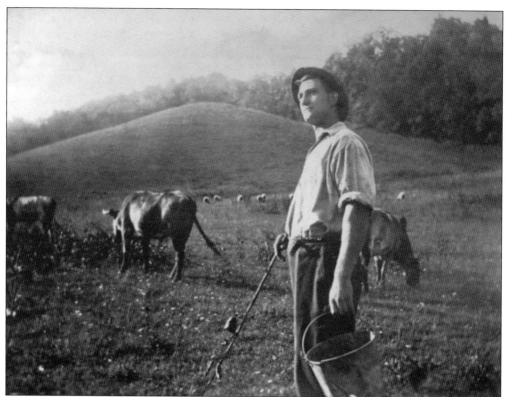

CATTLE AND SHEEP. These photographs, likely taken between 1910 and 1920, show two farm activities, tending cattle and sheep. Both presumably depict Don J. Horton on his family farm at Vanderpool near Vilas. (Both, courtesy of James B. Mast Jr.)

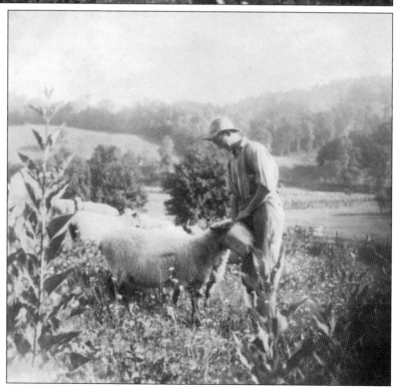

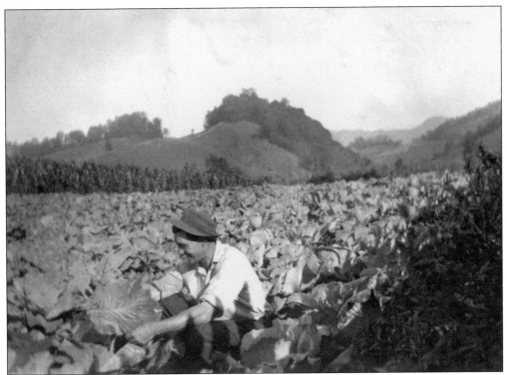

CABBAGE AND HAY. A farmer, presumably Don J. Horton on his family farm at Vanderpool near Vilas, tends to cabbage and hay, likely between 1910 and 1920. (Both, courtesy of James B. Mast Jr.)

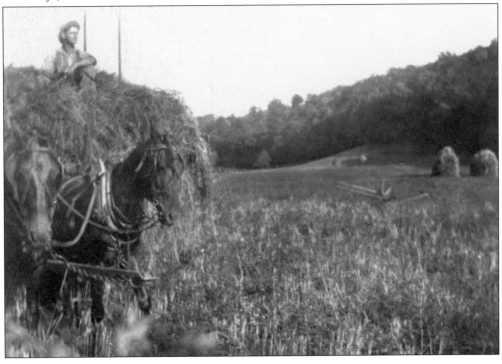

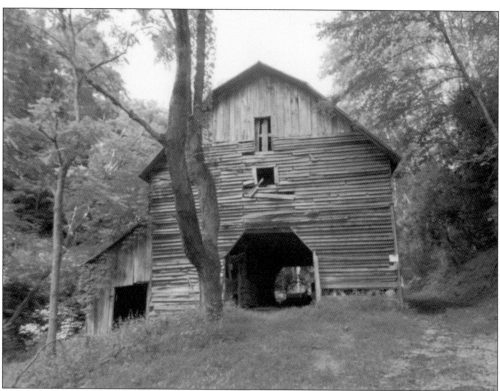

THE BARN. For much of the nation's history, most families farmed, and barns were indispensable in agrarian communities. This was certainly true of those living in Watauga County who tilled the soil and raised stock. The James Anderson Love barn (above), constructed in the 1860s, still stands on Rush Branch in western Watauga. The cover of the November 1960 issue of *The Carolina Farmer* (right) posthumously shows Lorenzo Dow Ward (1865–1958) of Laurel Creek Township walking across a footbridge from his barn with pail in hand, perhaps returning from a milking. Note the tobacco hanging to cure inside the front entrance of the barn. (Above, courtesy of David Harmon.)

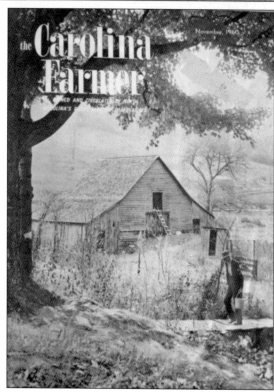

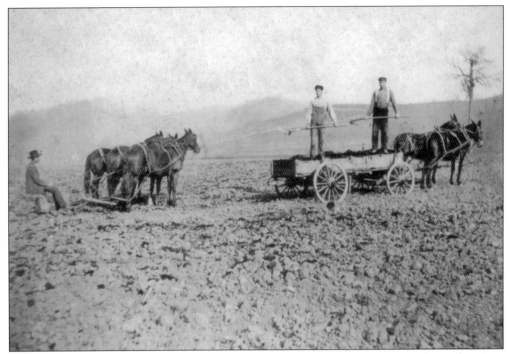

SHIPLEY FARM. Nathan Shipley came to Watauga County after 1855. His brother-in-law Dan Bradley owned a farm on present-day Linville Creek in Vilas. In 1872, Shipley purchased 115 acres of the farm. His son James Huston "Huse" Shipley subsequently assumed operation and eventually left the farm to his nephew Robert Gray "R.G." Shipley Sr. In 1897, R.G.'s father, William Edwin Shipley, brought the first purebred registered Hereford bull into North Carolina, leading it from Virginia behind a horse-drawn buggy. Above, Huse Shipley drives a three-horse team, pulling a harrow while farmhands spread manure. Shown below in 1939 are, from left to right, county agent H.M. Hamilton, W.E. Shipley, and possibly farmhand Oscar Whittington. (Above, courtesy of Nannie Greene; below, courtesy of Special Collections Research Center, North Carolina State University Libraries, Raleigh, North Carolina, PhC8_306.)

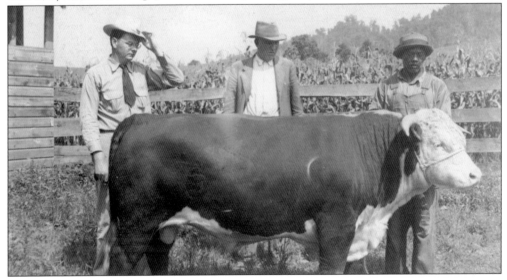

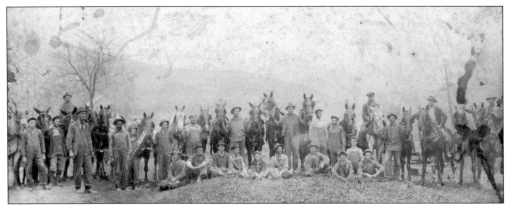

HORSES APLENTY. Although the location and circumstances of this early 1900s gathering are unknown, it attests to the importance of horses (18 pictured here) in rural life and agrarian society. The only possible identification is Watt Henson of Cove Creek, holding the halters of two horses just left of center.

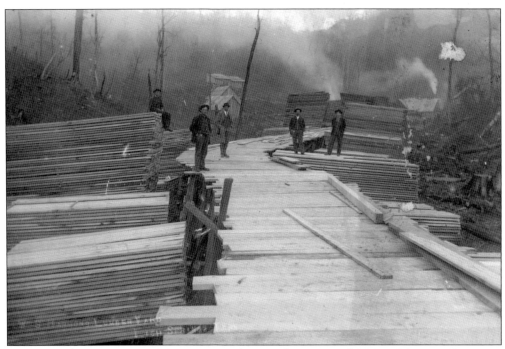

WILEY SMITH HARMON LUMBER YARD. Wiley Smith Harmon (1876–1969) was a Wataugan who lived at Beech Creek and, at various times, worked as a farmer, merchant, postmaster, schoolteacher, and lumberman. This photograph offers a glimpse into his lumberyard, which was located at Fish Springs near present-day Watauga Lake, in Carter County, Tennessee. (Courtesy of David Harmon.)

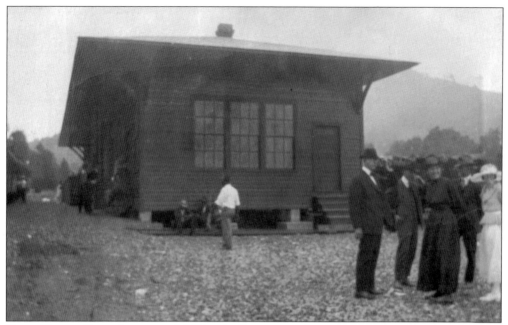

TRAIN DEPOT. Shown here around 1919 is the Boone train depot, serving Linville River Railway, a line of the East Tennessee & Western North Carolina Railroad. The depot stood near the corner of today's Depot and Rivers Streets. Standing with the group at right are Newton L. Mast (left) and his wife, Addie Horton Mast (in black dress). (Courtesy of James B. Mast Jr.)

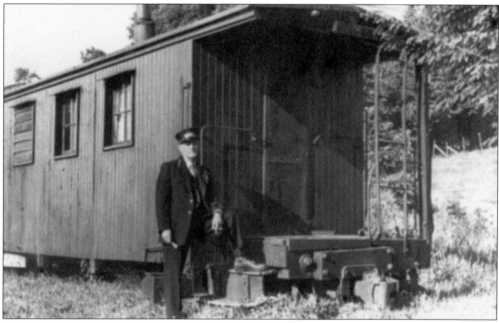

CY CRUMLEY. Cyrus Grover "Cy" Crumley (1885–1978) worked 54 years as a brakeman and conductor for the East Tennessee & Western North Carolina Railroad and conducted the daily passenger train between Boone and Johnson City, Tennessee. While stationed in Boone, Crumley lived in "Black Mariah" (pictured), an old caboose set off its wheels in the rail yard. (Courtesy of the Cy Crumley Scrapbook.)

TRAIN ON HODGES MOUNTAIN. A Linville River Railway engine pushes dump cars on a trestle on Hodges Mountain through Hodges Gap between Shulls Mills and Boone in 1920. Part of the East Tennessee & Western North Carolina Railroad, this line from Cranberry to Boone was known as the Little River Railway and was extended to Boone in 1919. (Courtesy of the Cy Crumley Scrapbook.)

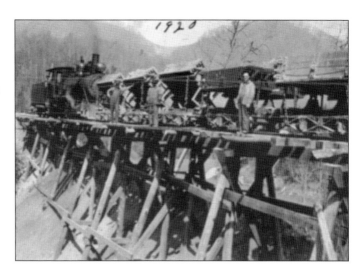

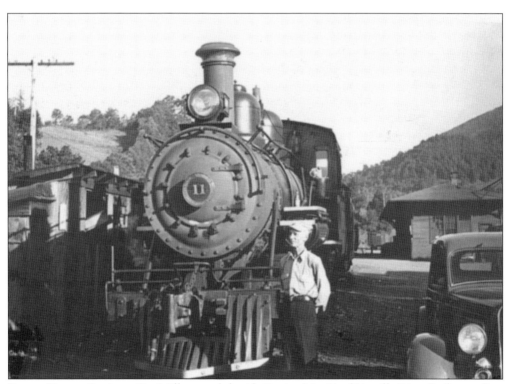

BOONE DEPOT. Engineer Jim Miller stands beside Engine No. 11 of Linville River Railway, a line of the East Tennessee & Western North Carolina Railroad. Boone depot and Rich Mountain are at right. This juncture approximated present-day Rivers Street through the Appalachian State University campus. ET&WNC, remembered by some as "Eat Taters and Wear No Clothes," was more affectionately known as "Tweetsie Railroad." (Courtesy of the Cy Crumley Scrapbook.)

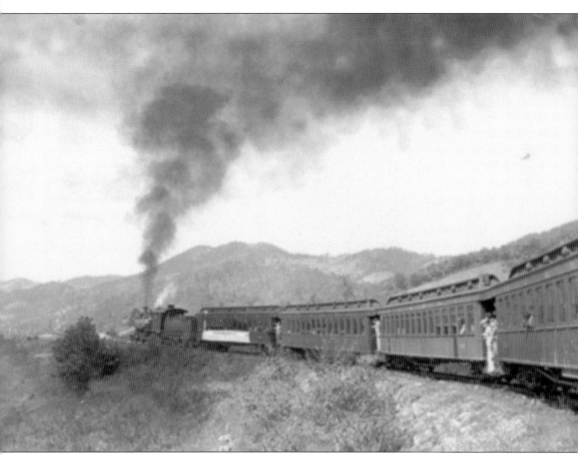

LAST RUN. This photograph, taken near Foscoe with Grandfather Mountain in the distance, captures one of the Linville River Railway's final excursions into Watauga County prior to the August 13, 1940, flood that ended its run here. The last train leaving Boone that particular morning did so among sheets of rain and on ground so saturated that it could absorb no more. Water cascaded down the mountains, and rivers and streams swelled. The train passed through two feet of water at Shulls Mills, and Grandfather Mountain appeared as a giant waterfall. The Linville River Railway (LRR) had made little money, and the flood's damage sealed its fate. The train reached Johnson City, but it faced washouts on its attempted return to North Carolina. Freight cars that had been left behind in Boone were removed by truck that September and October, and the track was likely removed in the spring of 1941, after the LRR was officially abandoned. (Courtesy of the Cy Crumley Scrapbook.)

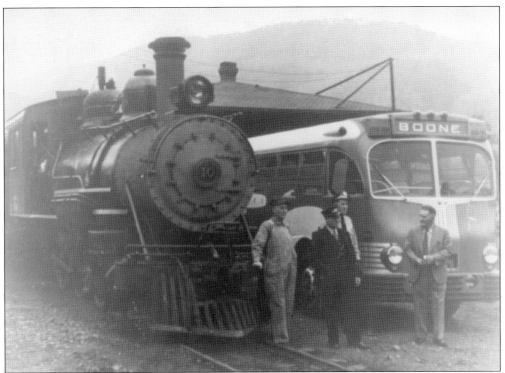

BY BUS OR BY TRAIN? This 1939 photograph at the Boone depot shows two modes of transportation—Linville River Railway's passenger train, and a bus of Atlantic Greyhound Line, which held rights serving Boone via Highway 221 and Independence, Virginia, and via Highway 421 and North Wilkesboro. From left to right are engineer Sherman Pippin, conductor Cy Crumley, an unidentified bus driver, and Herman Wilcox. (Courtesy of the Cy Crumley Scrapbook.)

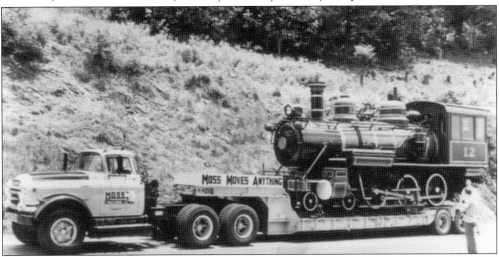

TWEETSIE HOMECOMING. In 1950, the East Tennessee & Western North Carolina Railroad sold engine No. 12 to a Virginia railroad. Cowboy star Gene Autry later opted to buy it, but Wataugan Grover Robbins bought Autry's option. Intending to display the engine at the Blowing Rock, Robbins ultimately put it into operation at the Tweetsie Railroad theme park. Here, in 1957, the refurbished engine is transported from Hickory to Blowing Rock. (Courtesy of the Cy Crumley Scrapbook.)

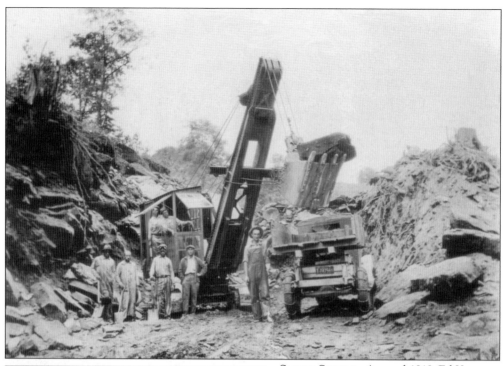

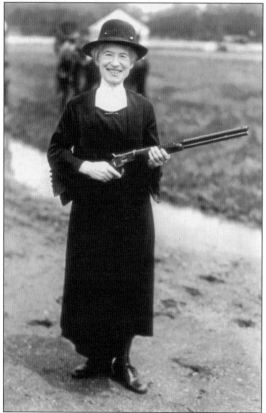

STEAM SHOVEL. Around 1919, Ed Yates (1891–1959) of Shawneehaw Township began operating a steam shovel to build roads, including those from Todd to Elk Park (NC 194), Warrensville to Trade (NC 88), and Boone to Blowing Rock (US 321). A major undertaking was the road from Matney to Valle Crucis in the 1930s. In 2012, this section of NC 194 was named Ed Yates Highway. In this photograph, Yates is seen inside the cab, hand on lever.

TOURISM. A key Watauga County commerce source for more than a century, tourism primarily originated in Blowing Rock among its many hotels and boardinghouses and subsequently spread to Boone and beyond. Seen here is famed American sharpshooter (and tourist attraction in her own right) Annie Oakley (1860–1926). Once a Green Park Inn guest, Oakley operated a shooting range at Mayview Manor in 1924. (Courtesy of the Library of Congress.)

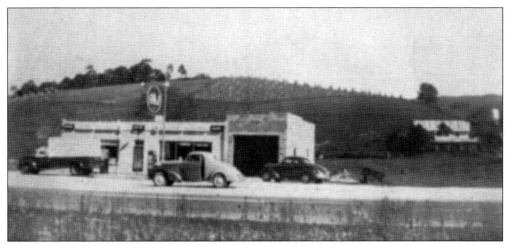

BROWN'S RESTAURANT. This postcard, possibly dating from the 1940s, shows Brown's Restaurant in Vilas. It was located on US Highway 421, four miles west of Boone, at the site of what was formerly Adams Building Supply. The popular restaurant was operated by Roy and Naomi Vines Brown and their daughters Lavola and Lennis. (Courtesy of the Bobby Brendell Postcard Collection, Watauga County Historical Society, and the Digital Watauga Project.)

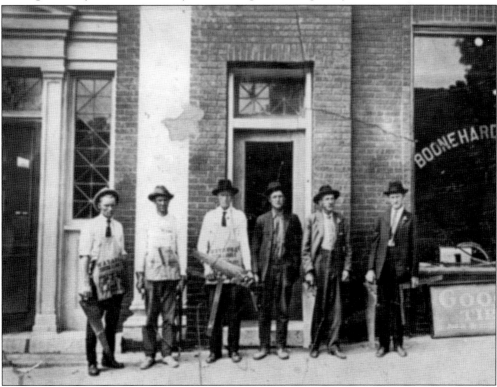

ROW OF CARPENTERS. This c. 1922 photograph shows a row of carpenters between the Watauga County Bank and Boone Hardware. The hardware store became Farmers Hardware in 1932, after Boone Hardware's Depression-era bankruptcy. From left to right are unidentified, Enzer Beach, Will Hodges, Frank Culler, unidentified, and Pink Hodges. (Courtesy of the Historic Boone Collection, Watauga County Public Library, and NC Digital Heritage.)

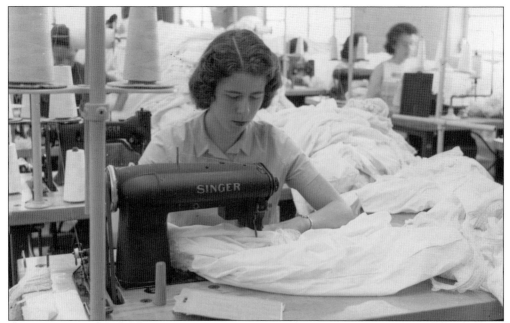

SHADOWLINE. Employees are seen at Shadowline, a longtime women's lingerie manufacturer, in 1958. Along with a kraut factory, shoe plant, Vermont American, and the International Resistive Company (IRC), Shadowline was one of several industries that operated in Boone, employing many Wataugans. All have closed, although the former Shadowline facility still stands on Shadowline Drive. (Courtesy of Special Collections Research Center, North Carolina State University Libraries, Raleigh, North Carolina, UA100_099.)

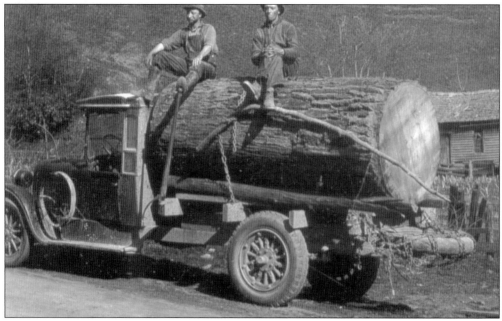

LOG HAULING. From the 1910s to the 1930s, logging was a major industry in this region. Here, Claude Davis (left) and Charles Isaacs sit atop a massive log that seems to be stretching this truck's capacity. (Courtesy of Nannie Greene.)

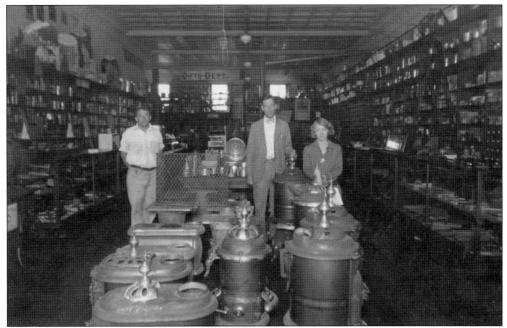

FARMER'S HARDWARE. This company was established by Clyde Greene and partners on King Street in 1924, down the block from its later, famous location beside the Watauga County Bank. This c. 1932 photograph of the interior of the store shows off an assortment of shiny stoves, among other wares. Posing from left to right are clerk Troy Norris, manager J. Frank Moore, and bookkeeper Ruth Cottrell. (Courtesy of Jack Henson.)

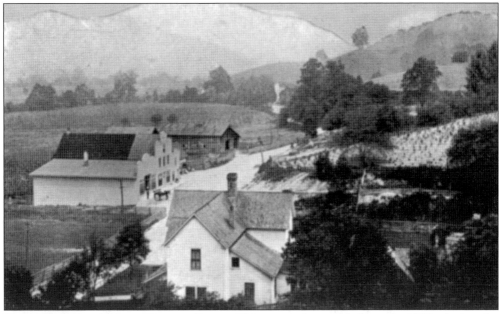

VALLE CRUCIS AND MAST GENERAL STORE. This postcard, possibly from the 1910s, depicts the Mast General Store in the heart of Valle Crucis. In the foreground is the home of the store's proprietor, Will Mast, and his wife, Emma. (Courtesy of the Bobby Brendell Postcard Collection, Watauga County Historical Society, and the Digital Watauga Project.)

LOCAL EATERIES. For many years, two of the most popular locally owned restaurants in Boone were the Town House and the Mountain House. Both were located alongside US Highway 321. The Town House Restaurant (above) was owned and operated by Frank and Frost Norris. Although the business no longer exists, the structure does, and is now home to Precision Printing. The Mountain House Restaurant (below) was owned and operated by Betty Austin. The building stood at the current site of Walgreens. The restaurant was then moved to the former Mom's Restaurant, on the present site of Cracker Barrel. It then relocated to New Market Center, where it remained until its closing. (Both, courtesy of the Historic Boone Collection, Watauga County Public Library.)

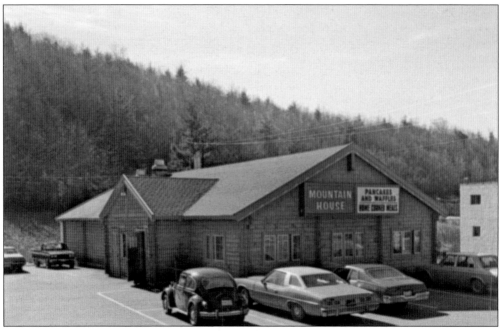

TIME FOR A TRIM. Beaver Dam native Lewis Reese (1900–1992) was a longtime barber in Boone, having gone into business with Jerry Wilson at what was once the Central Barber Shop. Reese later partnered with Joe Crawford at the Sanitary Barber Shop, beside the Gateway Restaurant in the John W. Hodges (now Vetro) building. Lewis and his wife, Blanche Henson Reese, resided on Grand Boulevard. (Courtesy of William Reese.)

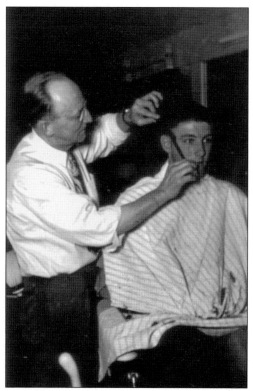

LOVILL LAW OFFICE. William Richard "Will" Lovill (1866–1953) practiced law in Boone alongside his father, Edward Francis Lovill. Their law office stood beside the county jail (now Proper Restaurant) on Water Street. This photograph shows the 1950s demolition of the office. This site was later home to a portion of the Heilig-Meyers Furniture Store, now occupied in part by Mellow Mushroom. (Courtesy of the Historic Boone Collection, Watauga County Public Library, and NC Digital Heritage.)

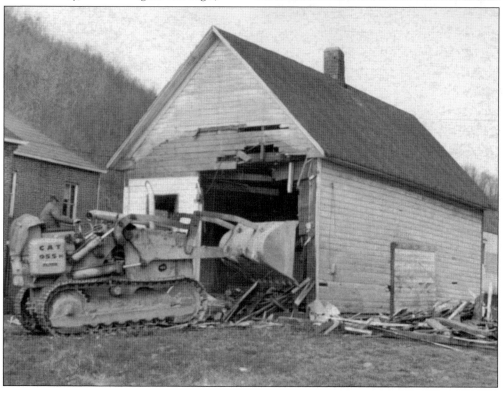

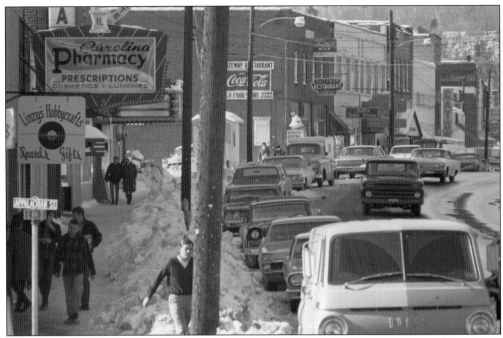

SNOW BANKS. This 1960s photograph of East King Street's intersection with Appalachian Street shows snowstorm remnants piled on the curb. Except for Appalachian Theatre (now being restored), most of the businesses seen here no longer exist. These include Linzy's Hobbycrafts Records & Gifts, Carolina Pharmacy, Sears, Gateway Restaurant, Bill's Shoe Store, Flowers Photo Shop, McGuire's Beauty Salon, Mix Mates, Catos, Crest, Farmer's Hardware, and Burgess Furniture. (Courtesy of University Archives, Appalachian State University.)

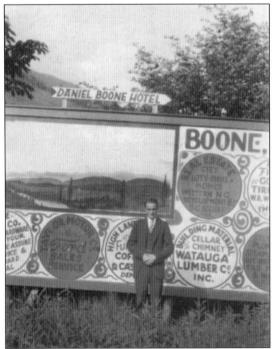

WELCOME TO BOONE! This early billboard, perhaps from the 1930s, advertises many businesses of the day, including the well-remembered Daniel Boone Hotel. Posing before it is James B. "Jim" Mast Sr. of Cove Creek. (Courtesy of James B. Mast Jr.)

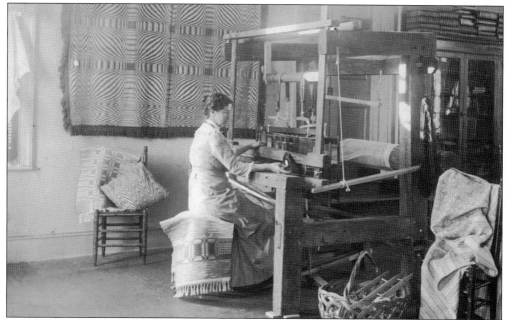

WEAVING. Around 1913, Pres. Woodrow Wilson's wife, Ellen, gave Appalachian women an opportunity to exhibit their skills. In refurbishing Wilson's White House bedroom, she incorporated weavings by women of western North Carolina and east Tennessee, including two large rugs hand-loomed by Allie Josephine "Josie" Mast (1861–1936). A resident of Valle Crucis, Mast (pictured) was one of Appalachia's best weavers. A sample of her weaving is in the Smithsonian Institution.

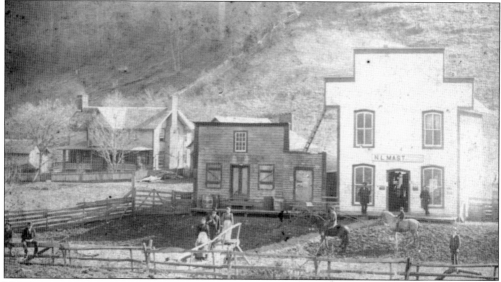

N.L. MAST HOME AND STORE. Newton Lafayette "Newt" Mast (1859–1929) was an early merchant in Cove Creek Township. His home and store were located in the community of Mast, near Laurel Branch between the Amantha and Silverstone communities. This photograph dates from the late 1890s or early 1900s. (Courtesy of James B. Mast Jr.)

N.L. MAST STORE. This photograph, dating from the late 1890s or early 1900s, provides a scenic view of the store, with Tater Hill rising in the background. Note the horses, wagon, and people scattered about the property, including three boys on a log footbridge at right and three little girls in the foreground. (Courtesy of James B. Mast Jr.)

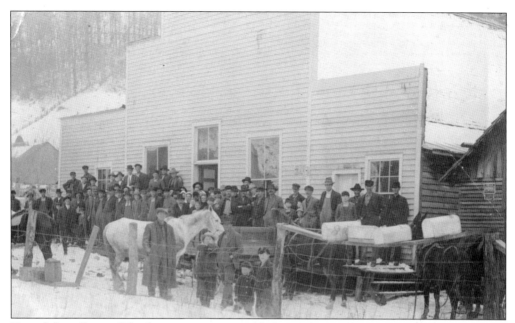

DOCK MAST STORE. This large group is assembled at Tarlton Lafayette "Dock" Mast's store on Brushy Fork, between Vilas and Boone, probably at the turn of the 20th century. This store and the Mast home were near Brushy Fork Baptist Church on "Boone Mountain" (US Highway 421). (Courtesy of Eude Moody.)

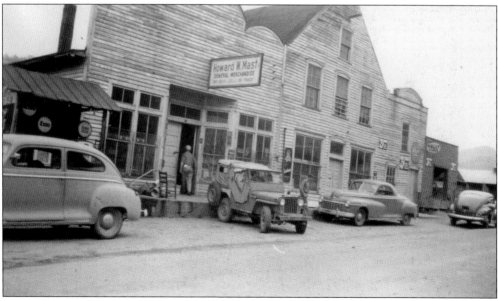

MAST GENERAL STORE. As early as 1860, Henry Taylor established a general store in Valle Crucis. In 1897, he partnered with his great-nephew Will Mast. Mast and his family were sole proprietors from 1913 until 1973, when the store, seen here around 1947, was listed in the National Register of Historic Places. Closed from 1977 to 1980, it reopened under John and Faye Cooper's ownership. (Courtesy of Diana Mast White.)

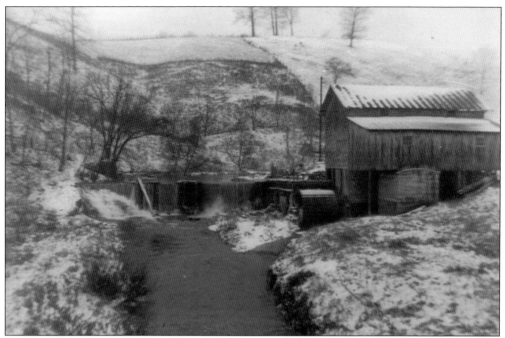

MAST MILL. In 1848, on Cove Creek, Joseph Harrison Mast built this dam and gristmill, later converted into Watauga's first roller mill. In 1915, it provided the county's first electricity. It was a community gathering place, as men swapped stories around the stove and youngsters swam, fished, and skated on the mill pond. Operational until 1960 and sold in 1974, the structure was converted by the new owners into a dwelling. By 1986, the mill race was gone. The wheel, deteriorated and washed into Cove Creek, was purchased and repurposed at a Michigan mill by 1988. The dam no longer existed by 1995. (Courtesy of Ben Mast.)

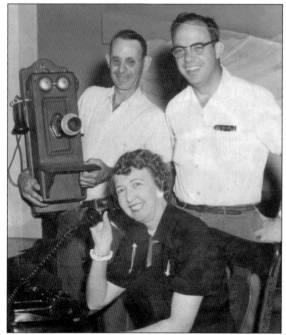

TELEPHONE CONVERSION. This 1956 photograph commemorates the conversion of local telephones to rotary-dial handsets. Pictured are Myrtie Herring Mast with David (left) and Joseph Farthing. (Courtesy of James B. Mast Jr.)

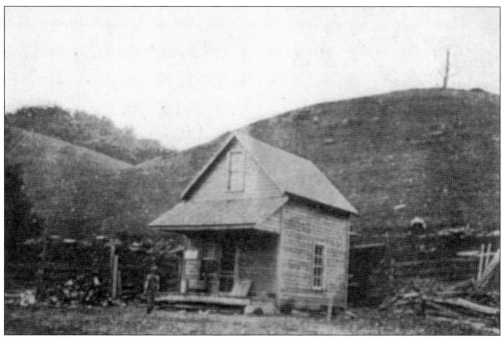

Cheese Factories. In 1914, the US Department of Agriculture began training mountain farmers to manage cheese factories. Most people were skeptical, until demonstrations proved that local cheese rivaled "store cheese." Approached with the prospect at Cove Creek, Pete Mast grew the venture into an organized cooperative in 1915. A small, 14-foot-by-16-foot building (above) was the first cheese factory in Watauga County. Built and furnished with equipment for only $400, it was operated by Vardry Mast at Cove Creek. The Beaver Dam cheese factory (below) was located at Sweetwater.

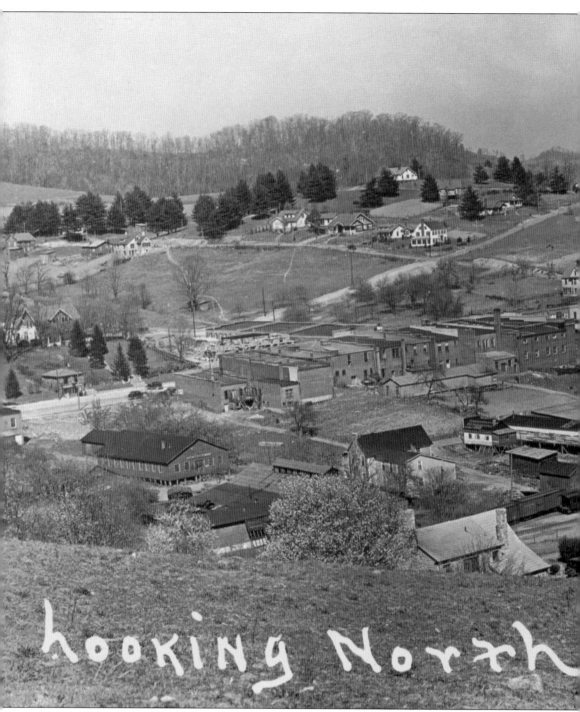

BOONE PANORAMA. This 1939 panoramic view of Boone offers one of the best-known sightings of the Linville River Railway and the train depot, seen just below and right of center at what is now Rivers Street. Note the stone bus depot being constructed beside the train depot. Other visible landmarks include the Linney home and law office on King Street (far left), the Boone Post Office under construction beside the Linney home, the Jones House and Daniel Boone Hotel

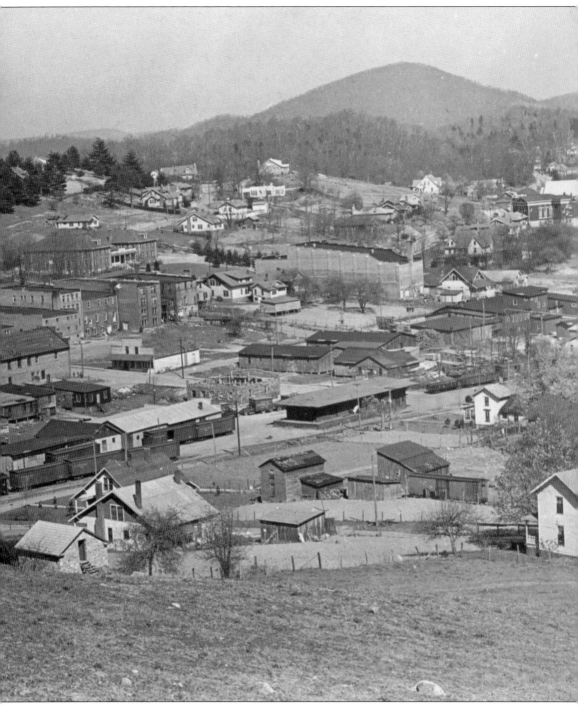

(above center), the large two-story building at center formerly used as the Daniel Boone Motor Company and county offices and now home to Farmer's Ski Shop on Depot Street, the Greene Inn and Appalachian Theatre with its stair-step roofline (right of center), and Boone Methodist and First Baptist Churches (far right). (Courtesy of the Cy Crumley Scrapbook.)

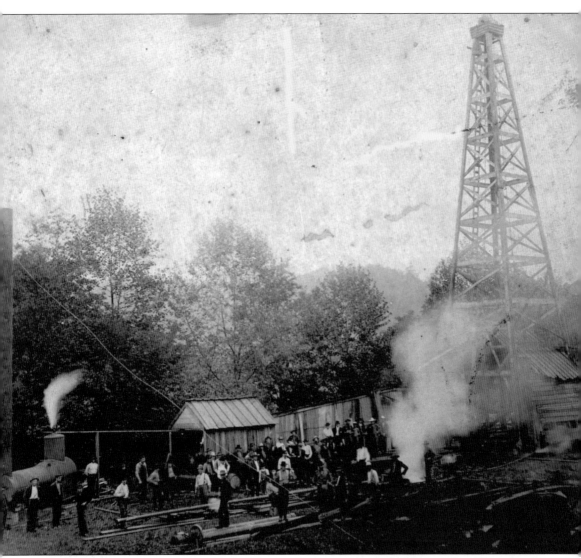

BUBBLING CRUDE? In August 1907, the *Watauga Democrat* reported, "The people of Cove Creek are elated over their prospect for oil." By March 1908, machinery for the first well arrived on the N.L. Mast property. By June, the newspaper reported, "The oil operations at Mast are going steadily on . . . the ponderous drill never being at rest from Monday morning until . . . [midnight] Saturday . . . and our people are looking to hear of great wealth being produced." By mid-July, solid rock and broken drills slowed progress. Three months later, the newspaper reported, "The oil men have gone." In 1909, Mast sued the Carolina Valley Oil & Gas Company for expenses. He advertised for sale, among other items, an oil derrick, engine, and boiler. The property sold at public auction at the courthouse door in Boone. Drilling had reached 700 feet, and Mast still believed that oil was there in great abundance, because the company had expected to strike at no less than 2,500–3,000 feet. Mast hoped to further pursue the venture, but it never materialized. (Courtesy of James B. Mast Jr.)

Two

Schools and Religious Life

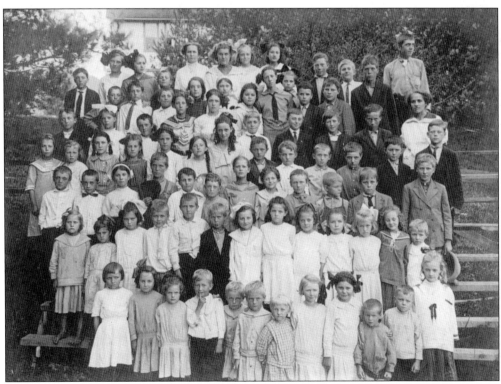

Boone Elementary Students. This fine-looking group of youngsters comprised the student body of Boone Elementary School in 1913. Among the most noticeable children are the identical twins, Howard and Raleigh Cottrell, at center in the first row. (Courtesy of the Historic Boone Collection, Watauga County Public Library, and NC Digital Heritage.)

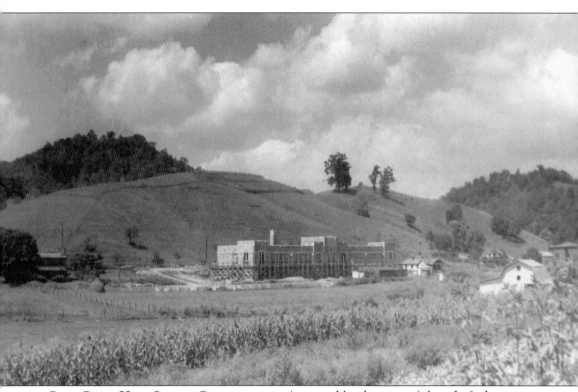

COVE CREEK HIGH SCHOOL CONSTRUCTION. Approved by the county's board of education in 1939, this Work Projects Administration endeavor was completed for the 1942–1943 school year. Its designer, Clarence Coffey of Lenoir, studied architecture in Chicago and was an apprentice draftsman to Frank Lloyd Wright. Exterior stone came from the Reeves Billings farm on Phillips Branch and the Ottie Bingham farm in Sugar Grove. Hemlock framing timber came from the Floyd Billings farm near Watauga River. Approximately 100 locals worked on the project, which served as the second Cove Creek High School until all the county's high schools were consolidated in 1965. It then served as Cove Creek Elementary School until a new school opened at Vanderpool in 1995. Listed in the National Register of Historic Places in 1998, it is the only school so distinguished in Watauga County. (Courtesy of Gladys Mast.)

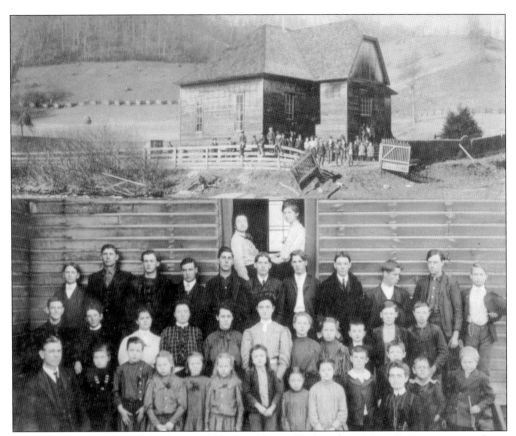

MAST SEMINARY. Newton Lafayette Mast leased an old church as Mast Seminary, seen above around 1906. The school stood near Old US Highway 421 and Laurel Branch in Cove Creek's Mast community. Among those shown in the above photograph are four Mast children: Jim (first row, center, with long hair), Mamie (second row, center), Tom (second row, third from right), and Maud (in doorway, left). Ed Harbin may be left of center in the third row. Rev. Olin P. Ader, the principal, is seated at far left in the first row, and teacher Mary Brown is seated at right in front. In the photograph below, taken around 1908, Miss Brown is seated at far right. The only identified students are the Masts: Mamie (standing, second from right), Maud (standing, sixth from right), Tom (standing, far left), and Jim (sitting, third from left). (Both, courtesy of James B. Mast Jr.)

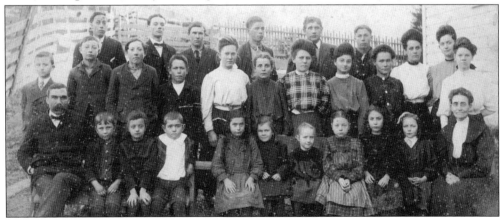

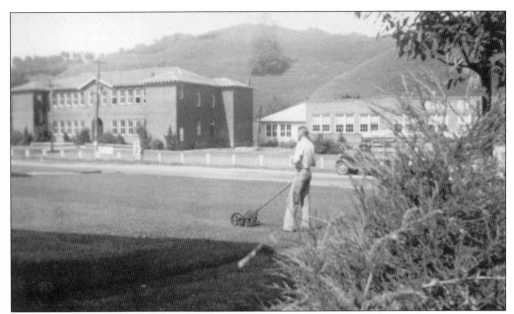

FORMER COVE CREEK SCHOOLS. Tom Moody, a former school principal and local merchant, trims his yard. Serving as his backdrop are the former Cove Creek Elementary School (left), built in 1922, and Cove Creek High School (right), built in 1927–1928. The buildings are no longer in existence, and the site is now home to the Western Watauga Community Center. (Courtesy of Eude Moody.)

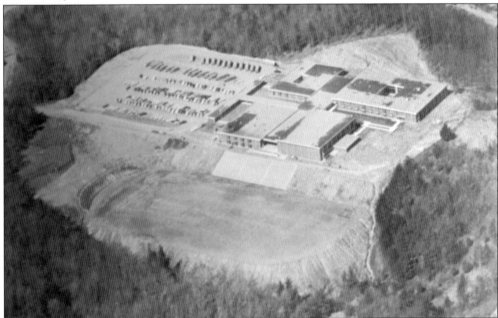

WATAUGA HIGH SCHOOL. Since the 1965 consolidation of Appalachian, Bethel, Blowing Rock, Cove Creek, and Watauga Consolidated High Schools, Watauga High School has served as the county's only secondary school. The original Watauga High School (pictured) operated near Highway 105 until 2010, when a new building was opened off of Old East King Street near Mount Lawn Memorial Park and Gardens. (Photograph by Hugh Morton with Grover Robbins.)

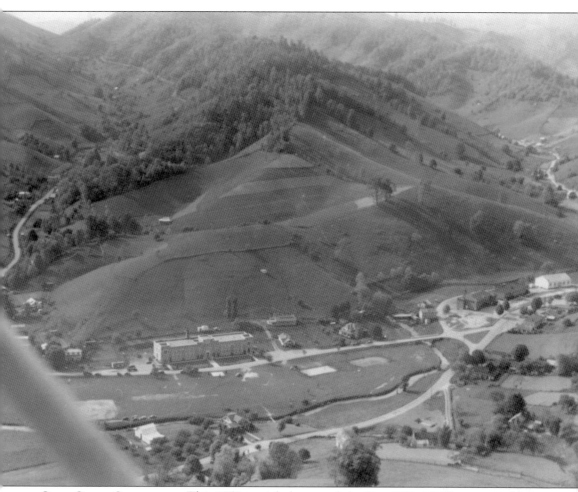

COVE CREEK COMMUNITY. This 1950s aerial photograph by Rev. H.K. Middleton provides a magnificent view of the valley surrounding the Cove Creek High School, framed by George's Gap Road (left), Isaacs Branch Road (right), and present-day Old US Highway 421 (foreground), paralleled by Cove Creek. The large house to the right of the school, beneath a growth of trees, is the David Bingham home. To the right of this house is the Mast Mill. The three buildings to the right of the mill are the original brick Cove Creek High School, the elementary school, and the white frame gymnasium. Below the grassy triangle to the right of center is the Deal home and farm. This was the general location of Camp Mast, a Confederate Home Guard base during the Civil War. The house in front of the school was the home of Cove Creek High School principal Sam Horton and his wife, Pearle, who taught French and civics at the school. The Dale Adams home is at far left. (Courtesy of Gladys Mast.)

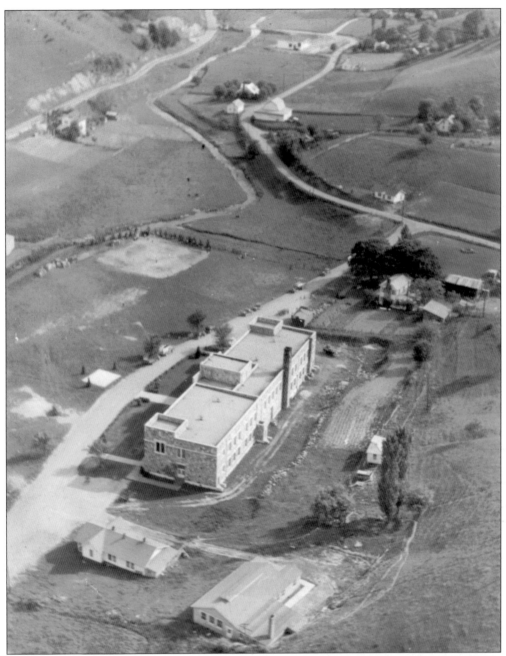

BIRD'S-EYE VIEW OF COVE CREEK COMMUNITY. Cove Creek High School is central to this 1950s aerial photograph by Rev. H.K. Middleton. At upper left is the Dan Mast home. At top center is the Coble Dairy, and at top right is the Hardy Mast home. Below the dairy is the Dewitt Brown farm, with its large white barn. The school custodian's home is in the foreground at left, with the community cannery to its right. The new gymnasium had not yet been constructed to the right of the school, but the house at far right was the original Lorenzo Dow Whittington home. It is now home to Mr. and Mrs. Dale Adams. (Courtesy of Gladys Mast.)

Rev. Barzilla McBride. A native of Rowan County and a veteran of the War of 1812, McBride (1790–1858) moved to present-day Watauga County, settling at Cove Creek by 1850, or earlier, as he preached at Roans Creek Church in neighboring Johnson County, Tennessee, in 1845. His son Andrew Jackson McBride, a Watauga County sheriff, was wounded in Stoneman's 1865 raid on Boone. (Courtesy of Ben Mast.)

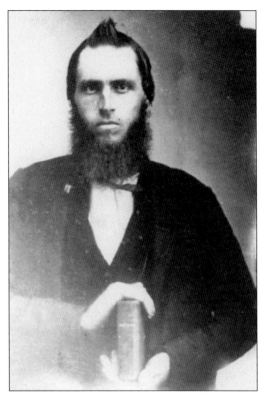

Rev. Christian Moretz. Moretz (1827–1905) came to Meat Camp in 1839 and was ordained as a Lutheran minister in 1850. One of his first pastorates was a church in Valle Crucis. At one point, he faithfully traveled via an old black mule to Alexander County's Salem Church for $50 per year. Moretz was an antebellum schoolteacher in Watauga County and operated a gristmill. Twice married, he fathered 16 children.

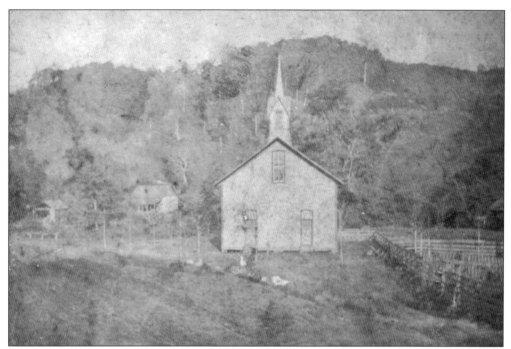

HENSON'S CHAPEL. These c. 1900 photographs are the only known images of the interior and full front exterior of the second Henson's Chapel Methodist Church building, which stood from 1888 to about 1931 in the Amantha community of Cove Creek Township. In the interior photograph, note the pews in the foreground, the piano or organ to the right, and the pulpit decorated in celebration of the death of the 19th century and the birth of the 20th. (Both, courtesy of James B. Mast Jr.)

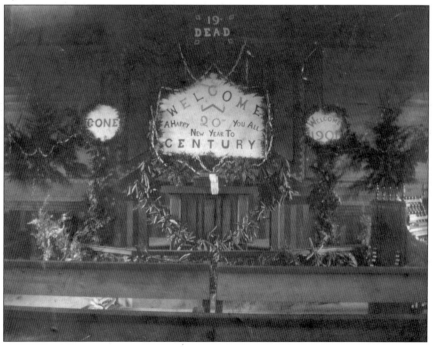

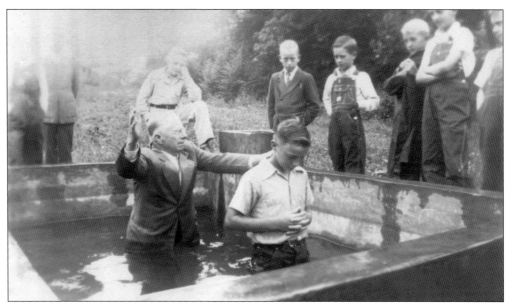

BRUSHY FORK BAPTISM. While many churches used local streams for baptisms, some had their own baptisteries. Here, young Harbin Moretz is baptized at Brushy Fork Baptist Church at Vilas in the early 1940s. (Courtesy of Eude Moody.)

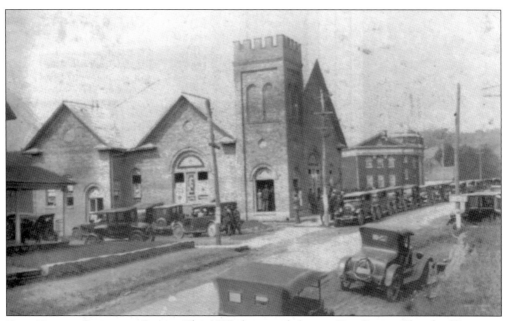

FIRST BAPTIST CHURCH OF BOONE. This 1925 photograph features First Baptist Church of Boone on East King Street, which is lined with the cars of those attending the funeral of prominent attorney and former North Carolina senator Edgar Stuart Coffey. Just beyond this church, to the right, is the Boone Methodist Church, which had been constructed two years earlier. Neither building exists today, although the current First Baptist Church occupies its predecessor's location.

Rev. Drewey Calvin Harmon.
"D.C." Harmon (1827–1904) helped organize Antioch and Brushy Fork Baptist Churches and pastored both, serving Brushy Fork for 25 years, except when he was in the Civil War. He also pastored Three Forks and Boone Baptist Churches and was register of deeds. In 1862, he was elected captain of Company D, 58th North Carolina Infantry Regiment in the Confederate army. He resigned shortly after to raise his family and to farm.

Old Henson's Chapel Parsonage.
This rare photograph shows the Henson's Chapel Methodist Church parsonage in the early 1900s. It stood beside the church, approximately on the site of the current parsonage, most likely from the 1880s to the 1940s. The current brick parsonage was built between 1943 and 1948 at a cost of $8,000 using free labor. (Courtesy of James B. Mast Jr.)

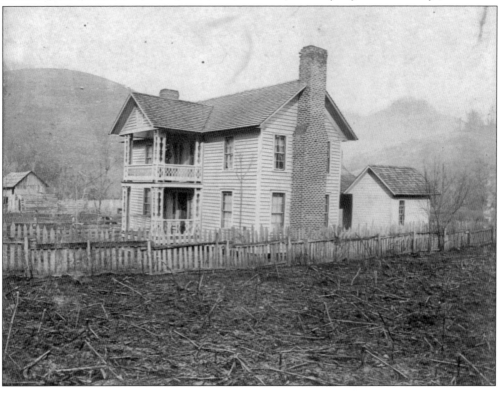

HENSON'S CHAPEL CONSTRUCTION.
These c. 1930 photographs show
construction of today's Henson's
Chapel United Methodist Church
at Cove Creek. The congregation
was organized in 1858, and the first
church, erected in 1868, was a small,
one-room log house standing on the
present-day church grounds. The
second church, a one-room frame
structure built in 1888, is at far left
in the photograph below. It stood on
the front lawn of the current church
and was later moved across the
creek to the Enoch Swift property,
at the corner of Henson's Branch
and Fletcher Branch, where it was
converted into a home. Construction
on the current church began in
1926 and was completed in 1931.
With its castle-like architecture,
vast auditorium, high tin ceiling,
and stained-glass windows, the
church is among the most beautiful
in Watauga County. (Below,
courtesy of James B. Mast Jr.)

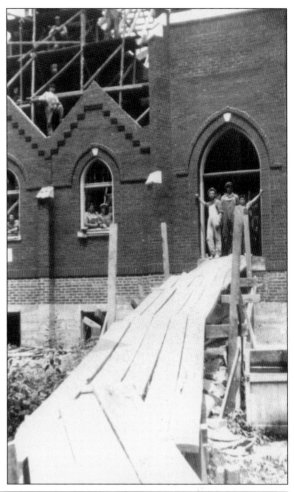

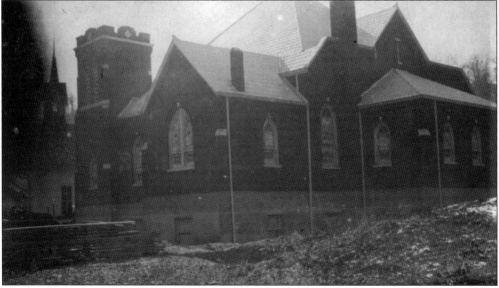

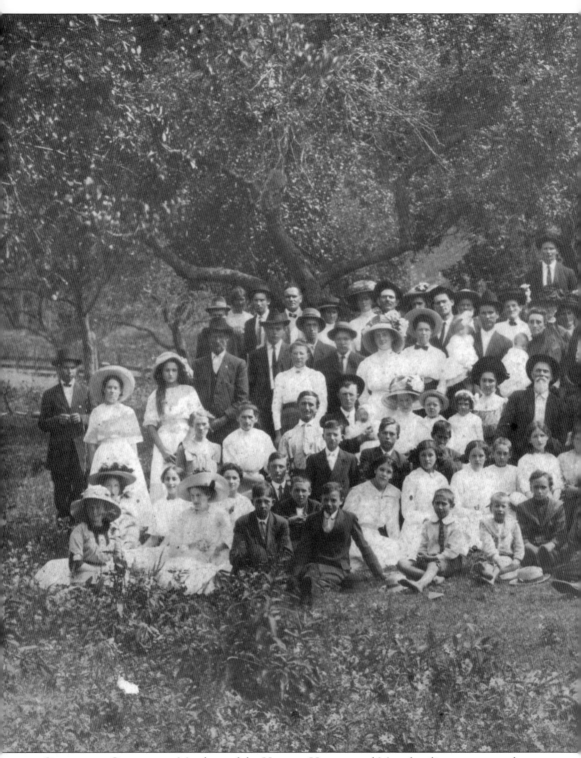

COMMUNITY GATHERING. Members of the Henson, Horton, and Mast families are among those represented at this large Cove Creek community gathering around 1910. Perhaps this is a Henson's

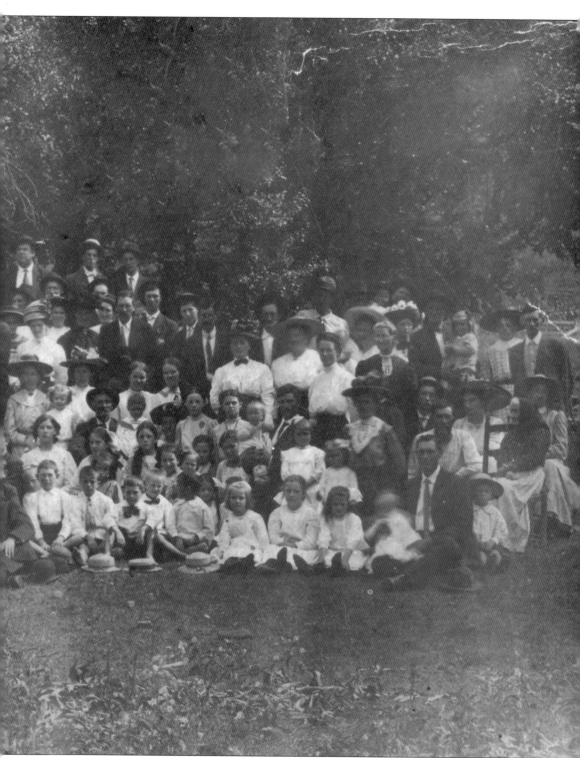

Chapel Methodist Church event at Amantha.

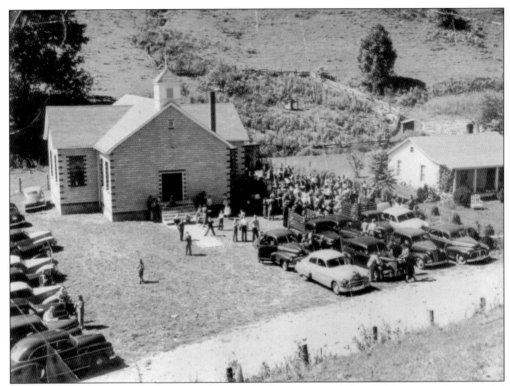

DINNER ON THE GROUNDS. These two photographs depict a typical church "dinner on the grounds" and feature the congregation of Willow Valley Baptist Church on Phillips Branch in the Sugar Grove community. The congregation was organized in 1935, and Willow Valley's second church building (above) was completed in 1951. The occasion of this dinner was the building's dedication on September 30 of that year. (Both, courtesy of Hilda Greer.)

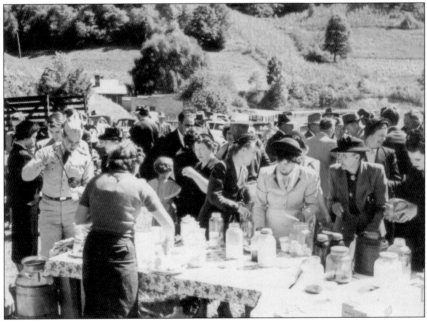

Three

HOME, FAMILY, AND LEISURE

WATT HENSON FAMILY. Here, three generations of the Henson-Horton family of Cove Creek pose around 1918. Shown are, from left to right, Inez and Mamie Henson, Mrs. Polly Councill Horton (rear), Amy and Don Henson, Watt Henson (holding Nell), and Maggie Horton Henson (holding Jack). Polly Councill Horton (1846–1936) was born on Brushy Fork in what is believed to have been the first brick home in present-day Watauga County.

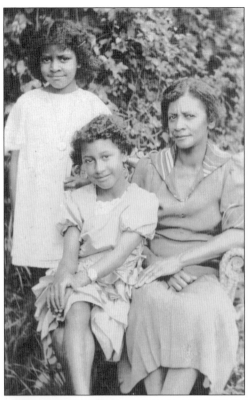

JUNALUSKA RESIDENTS. The members of this lovely trio are Marywill Young (left), Lala Grimes (center), and their grandmother Mamie Jackson. They were members of Boone's historically black Junaluska community. (Courtesy of Junaluska Heritage Association.)

PORCH GATHERING. This c. 1913 photograph shows a casual gathering at Sugar Grove. From left to right are (first row) Jack Mast (holding niece Lucy Glenn), Dalty Glenn, Ophelia Bingham, and Alice Mast; (second row) Mary Smith Combs (1845–1925), Finley Patterson Mast (1832–1924), Myrtie Mast Glenn (holding daughter Gladys), Jennie Bingham Mast (holding son Edward), Alice Smith Bingham, and Bessie Bingham Mast.

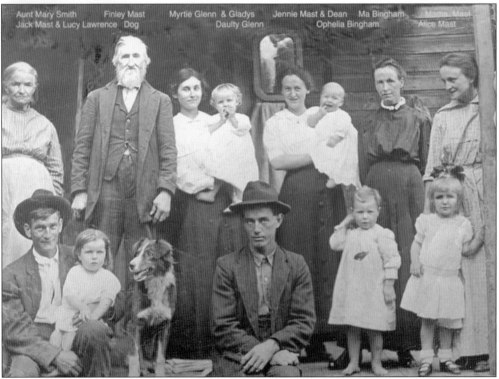

Family Portrait. This exceptionally clear photograph, taken around 1912, shows Callie Matheson Shull (1880–1963) of Cove Creek with her sons Ross Matheson (holding his half-brother Bill Shull) and Sam Shull. A dog, in a relaxed and seemingly content pose, rests its head against its master's leg.

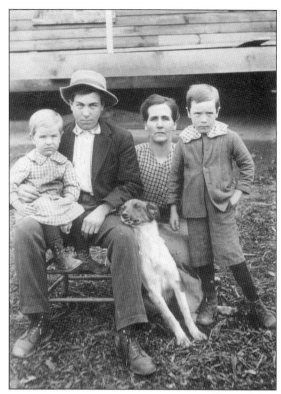

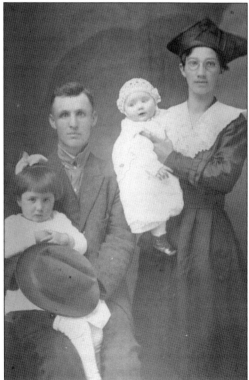

Orren Harmon Family. This photogenic family, shown around 1920, includes Orren Harmon (1892–1947), his wife, Emma Shull Harmon (1895–1993), and their two oldest daughters, Mattie Lou (1917–2012, left) and Jamie (1919–2003). Mattie Lou Wilson and Jamie Henson were highly respected and fondly remembered educators, teaching many years in the Watauga County schools. Mattie Lou taught most notably at Cove Creek and Watauga High Schools, and Jamie at Cove Creek Elementary School.

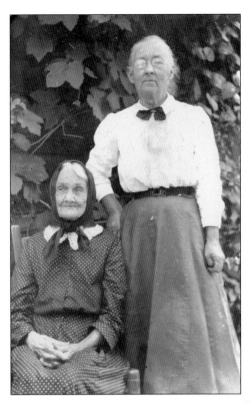

FAITHFUL SERVANTS. For decades, Polly Cornell (1824–1921) and daughter Amanda "Mandy" Cornell (1852–1940) were domestic servants in Boone and Cove Creek. Polly (seated) served three generations of the Councills and Hortons. When Benjamin Councill built his home in the 1840s on Brushy Fork in what is now known as Vilas, Polly cooked for the workhands constructing the house. (Courtesy of James B. Mast Jr.)

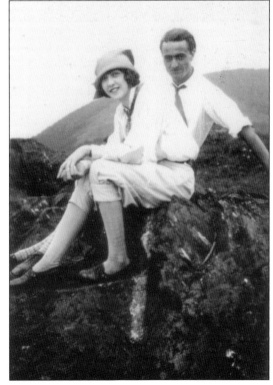

ON TOP OF TATER. This young courting couple, attired in stockings, knickers, crisp white shirts, and neckties, are Jim Mast (1901–1969) and his future wife, Myrtie Herring (1905–1975), in a moment of repose on Tater Hill in 1925.

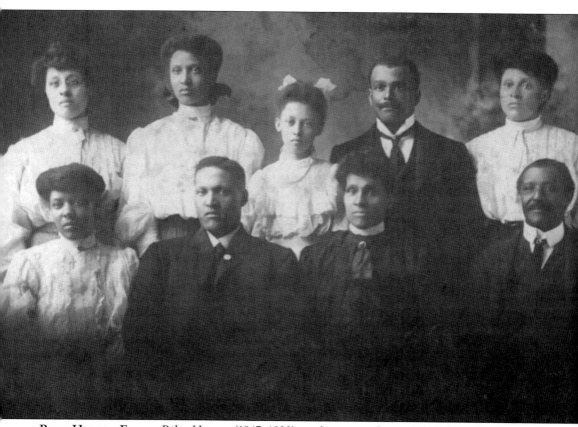

RILEY HORTON FAMILY. Riley Horton (1847–1930) was born into slavery. His father, Jake Horton, was a slave owned by Watauga County sheriff Jack Horton, and his mother, Patsy Mast, was likely a slave of the Mast family. Riley and Sheriff Horton's son Jim were close friends, and Riley and his family lived for a time on the Horton farm. "Uncle Rile," as he was known, played the fiddle at square dances and cooked at Jim's fish fries. By 1900, he moved his family to Johnson City, Tennessee. In 1909, they relocated to San Jose, California, where Riley died. This c. 1905 portrait of his family shows, from left to right, (first row) Mary E. "Mamie" Horton, James Washington "Jim" Horton, Jane Horton (Riley's wife), and Riley Horton; (second row) Adeline "Addie" Horton, Carrie Horton, Dortha Horton, Richard Gwyn (Riley's son-in-law), and Martha "Mattie" Horton Gwyn. (Courtesy of Sourisseau Academy for State and Local History, San Jose State University.)

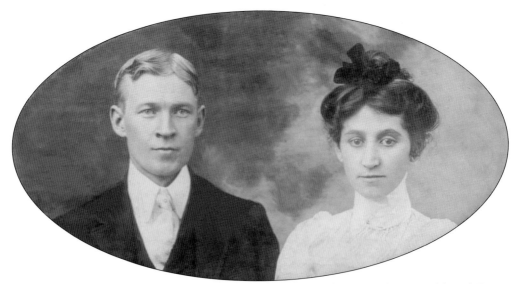

MAST-BAIRD WEDDING. This handsome newlywed couple, Will Mast (1876–1959) and Emma Baird (1877–1963), were married on April 9, 1902, at Valle Crucis. Mast began his mercantile career working with his great-uncle Henry Taylor at Valle Crucis, eventually becoming the sole proprietor of the business, the now-famous Mast General Store. Emma was a daughter of former Watauga County sheriff David Franklin Baird. (Courtesy of Diana Mast White.)

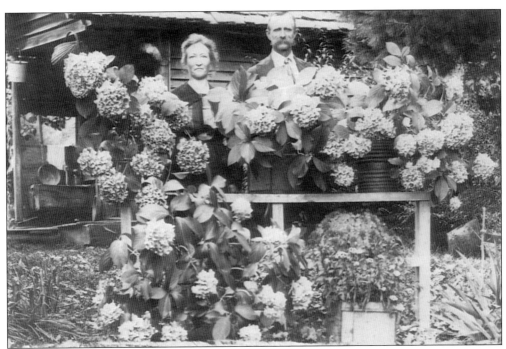

HARDY HYDRANGEAS. Cousins Louisa Wilson and Roby Wilson of North Fork Township are surrounded by no shortage of blooming hydrangeas in this photograph, probably taken between 1900 and 1910.

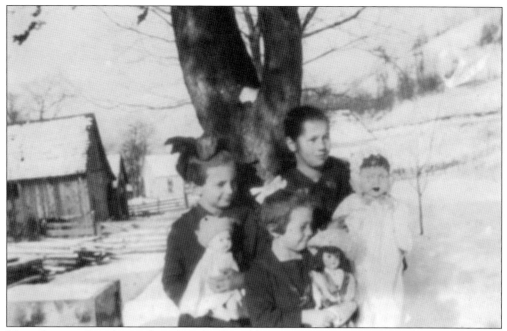

MAST SISTERS. Daughters of Dock and Effie Harbin Mast of Brushy Fork pose in the early 1920s. From left to right, Earlene, Eude, and Gladyce Mast show off their porcelain baby dolls on a snowy day, perhaps Christmas. (Courtesy of Eude Moody.)

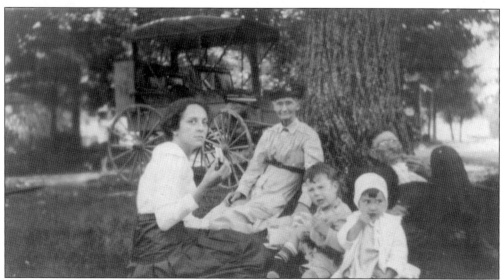

BLOWING ROCK PICNIC. Leaning against a tree at a picnic in Blowing Rock around 1917 are Jim and Polly Councill Horton from the Vanderpool community near Vilas. Accompanying them are their daughter-in-law Sadie Splitstone Horton (left) and grandchildren Howard and Mary Jeannette, who were visiting from Farrell, Pennsylvania.

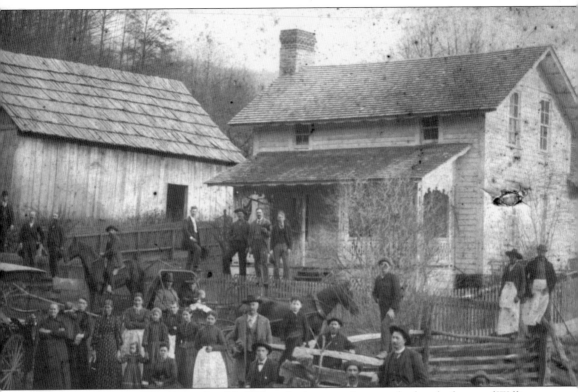

VILAS GATHERING. This December 26, 1893, gathering was photographed at the home of William Hamilton "Bill" Horton (1834–1913) and his wife, Temperance Caroline "Carrie" Shull Horton (1838–1913). This house still stands on US Highway 421 between Vilas and Vanderpool at Cole Drive, which leads to Cole's Meat Processing. The barn in the photograph no longer exists; it was located approximately on the site of Buddy and Tammie Spears's current home. The couple at center foreground may be Bill and Carrie Horton. The man mounted on a horse to the left is Bill and Carrie Horton's nephew Jim Horton. Jim's brother Dave Horton, and Dave's wife, Sue Mast Horton, are sitting in the carriage. Just below Jim's stirruped foot stands his wife, Polly Councill Horton. She and her daughter Maggie hold the hands of an unidentified little girl. Note the two black men in aprons at right. The man at far right is Riley "Uncle Rile" Horton, a former slave known to have cooked at Horton family gatherings.

FINLEY AND JOSIE MAST HOME. The Finley and Josie Mast home at Valle Crucis is seen here around 1900, many decades before it became the well-known Mast Farm Inn. It is alive with activity as family members or visitors gather in the yard while laundry dries on an upper porch and a young woman leans out of a window.

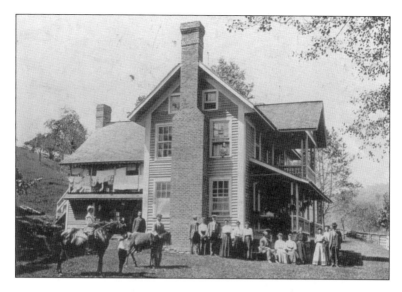

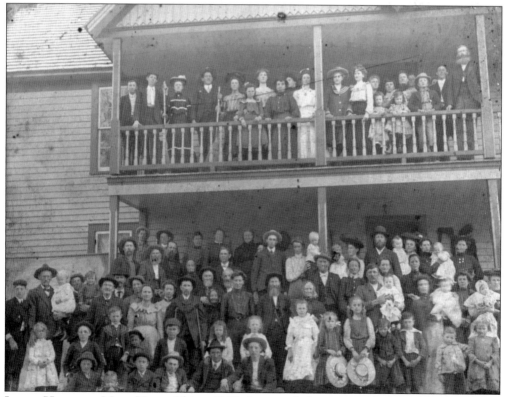

JOSEPH HARRISON MAST HOME. This c. 1900 photograph features a gathering of family, friends, and neighbors of Joseph Harrison "Joe" Mast (1827–1915) at his Sugar Grove home. Mast is at center with a hat and long beard. Many of his children and their families are included, as well as his brother Finley Patterson Mast and first cousin Rev. Drewey Calvin Harmon. (Courtesy of Gladys Mast.)

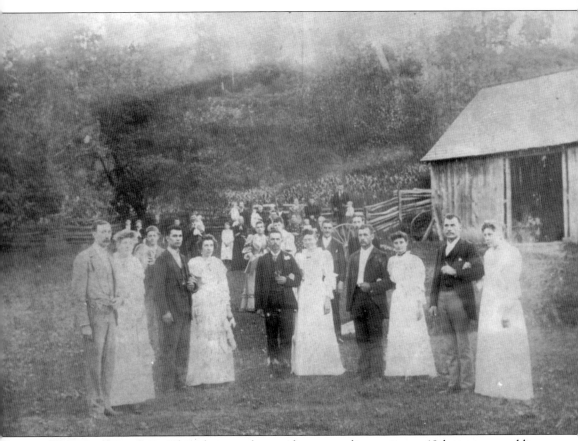

WEDDING RECEPTION. This photograph provides a rare glimpse into a 19th-century wedding reception. This reception was given on August 24, 1893, by J.C. Shull at Shulls Mills for Adolphus Monroe "Mon" Mast and his bride, Sarah Ellen Moore Mast. They were married the previous day in Caldwell County. The *Watauga Democrat* reported, "The number in attendance to witness the nuptial festivities was forty. The next day, being bright and lovely, fourteen of the number started for the reception at Shull's Mills. Arriving about 5 p.m. there were thirty-six people waiting to greet and congratulate. [After supper], the large crowd went out on the grassy lawn and stood before Mr. Rich, the photographer, and had their beauty struck." (Courtesy of James B. Mast Jr.)

HICKS HOME ON BEECH MOUNTAIN. Nathan and Rena Hicks and their daughter Nell stand above their Beech Mountain home in 1938. The vast beauty of three states—North Carolina, Tennessee, and Virginia—can be seen in the sweeping and inspiring vista behind them. (Courtesy of the Warner family.)

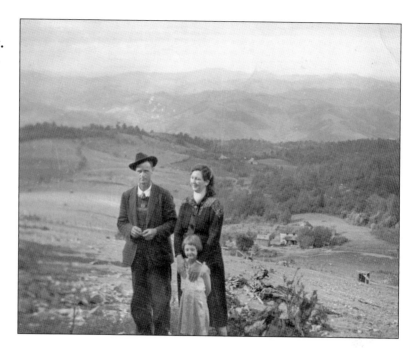

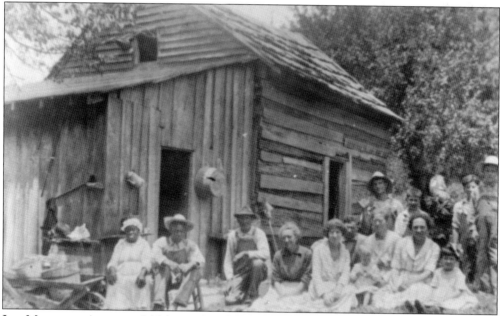

JESS MITCHELL. A native of Alabama, Mitchell (c. 1849–1928) lived and worked with his family on the Horton farm at Vanderpool. This c. 1920 photograph shows Jess and his wife, Drucilla, seated at left in front of their log cabin. They are posing with members of the Horton family. From left to right are (seated) Frank Horton, Addie Horton Mast, three unidentified, Maggie Horton Henson, Sadie Splitstone Horton, and Mary Jeannette Horton; (standing) Don Horton, Howard Horton, and two unidentified.

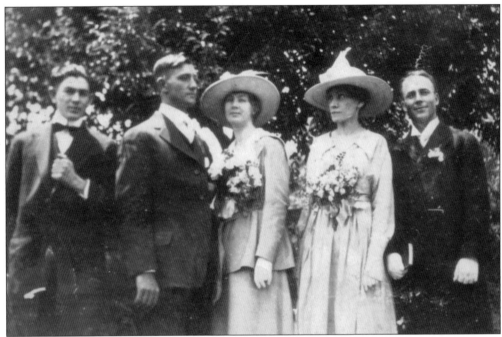

HORTON WEDDING. This 1917 portrait captures the wedding party of Don J. Horton (1887–1972) (second from left) and his bride, Annie Chandler Horton (1892–1987, center). Horton, a farmer and veterinarian, lived at the old Horton homestead at Vanderpool. Built in 1848 by Horton's grandfather, Watauga County sheriff Jack Horton, it was continuously lived in by family until it burned in the 1980s, Annie Horton being its last occupant.

BUD HARBIN FUNERAL. Prior to the widespread use of funeral homes, it was not uncommon for bodies of deceased family members to be prepared for burial at home and for funeral services to be conducted there. This photograph depicts the June 1938 funeral of William Henry "Bud" Harbin at his home on Laurel Branch in the Cove Creek community. (Courtesy of Eude Moody.)

SHADED LANE. This c. 1915 photograph shows, from left to right, printer T.B. Moore, Sallie Jurney Rivers (1861–1924), R.C. Rivers Sr. (1861–1933), and Calvin Cottrell (1843–1923). They are seen outside of the Rivers home on King Street in Boone. (Courtesy of Jack Henson.)

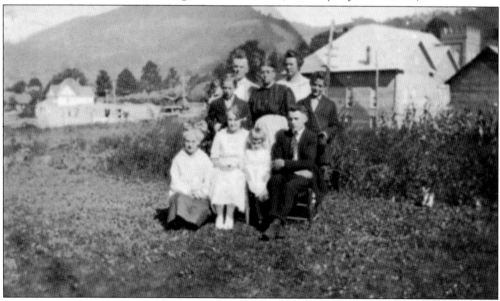

DAVID JONES COTTRELL FAMILY. Posing here are, from left to right, (first row) Ruby, Ruth, Floy, and Dallas Cottrell; (second row) Raleigh and D.J. Cottrell, Mrs. Charlotte Moore Edmisten (Mrs. Cottrell's mother), Texie Edmisten Cottrell, and Howard Cottrell. This c. 1919 photograph provides a glimpse behind King Street, the backside of the First Baptist Church, and the Jones House (far left), built in 1908. (Courtesy of Jack Henson.)

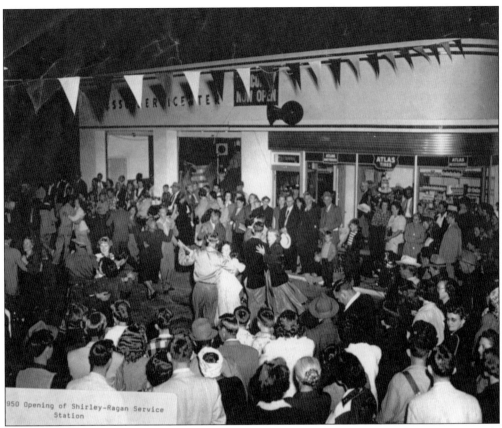

950 Opening of Shirley-Ragan Service Station

GRAND OPENING. This festive occasion, with music and dancing, was the 1950 grand opening of the Shirley-Ragan Esso Service Center at the corner of Hardin and Howard Streets on US Highway 321 South. This station, operated by Guy Shirley and Dave Ragan, still stands as a Citgo station beside the Dan'l Boone Inn. (Courtesy of the Historic Boone Collection, Watauga County Public Library, and NC Digital Heritage.)

ROCKY CLIFFS. This group of ladies on an outdoor adventure in the 1920s includes, from left to right, possibly Mary Jeannette Horton, Polly Councill Horton, Maggie Horton Henson, Sadie Splitstone Horton, and possibly Susie Baird Horton. A note on the back of the photograph states that they would have climbed to the top, but they were afraid of rattlers.

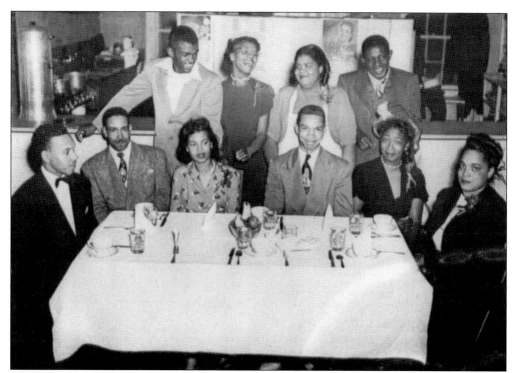

THE CHOCOLATE BAR. The Chocolate Bar was a popular café and gathering place for residents of the Junaluska neighborhood of Boone in the 1940s and 1950s. Its manager, David "Skeet" Clayborn, stands in the back at right. The building still exists and is presently utilized for storage by Austin Barnes Funeral Home. (Courtesy of Junaluska Heritage Association.)

GUITAR SERENADE. This c. 1938 photograph shows Iris Harmon (1911–1988) and his wife, Rose Edna Yates Harmon (1921–2015). At the time, they were likely an unmarried, courting couple.

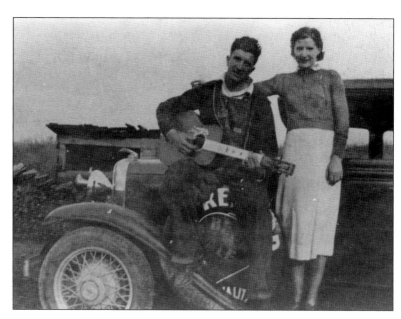

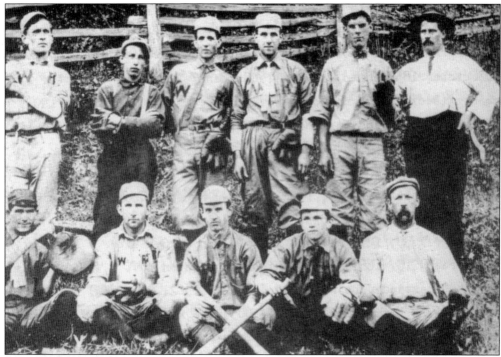

PLAY BALL! Baseball may have been introduced to North Carolina by Union soldiers playing at Salisbury Prison. The sport spread rapidly, and virtually every town had a team by the 20th century. Baseball became increasingly popular in Watauga County, both at the college and among the public. Appalachian Training School's first team took the field in 1903. An early *Watauga Democrat* mention of baseball was a 1904 game between Poplar Grove and Bamboo. The above photograph was taken at Watauga Falls in 1916. Shown are, from left to right, (first row) John Ward, Custer Ward, Don Ward, Ben Ward, and Dave Warren; (second row) Roe Clyde Privett, Omar Baird, Aubyn Farthing, Will Ward, R.F. Ward, and Ab Dotson. Shown below is Appalachian Training School's baseball team in Boone, also in 1916. (Below, courtesy of University Archives, Appalachian State University.)

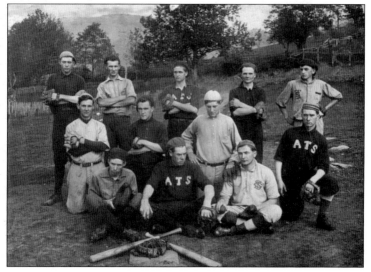

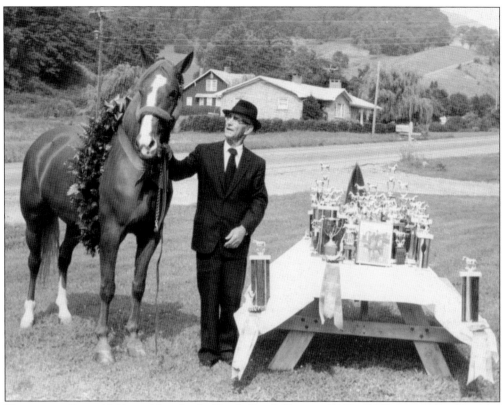

HORSEMAN. From 1966 until his death, "Little Don" Henson (1910–1990), pictured at his Vilas home with his retiring horse, King, was instrumental in organizing a popular annual horse show. Originally called Cove Creek Horse Show, it was renamed Watauga Horse Show. It was first conducted at the old Cove Creek School, then at Vanderpool. Cove Creek Riding Club president for more than 20 years, Henson's trophies attest to his horsemanship.

HUNTING PARTY. Posing here around 1900 are, from left to right, Boone's first mayor, William Lewis Bryan (1837–1928); James Dudley "Crack" Councill (1861–1936); and Col. Joseph Beckeweth "Joe" Todd (1822–1903).

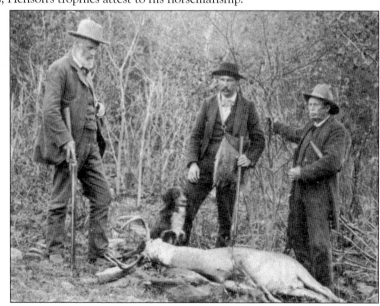

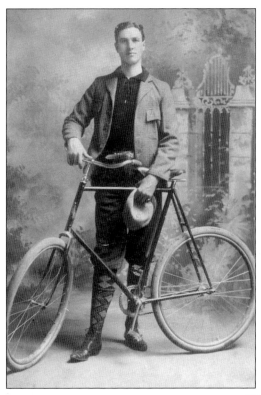

BICYCLING BLACKBURNS. By the start of the 20th century, cycling had become an increasingly popular form of recreation in the United States, although it rapidly declined between 1900 and 1910 as automobiles became a preferred mode of transportation. By the 1920s, bicycles were primarily considered to be children's toys, and by 1940, most bicycles manufactured in the United States were made for children. In these turn-of-the-20th-century photographs, Edmund Spencer Blackburn (left) and his nephew George Washington Blackburn (below) pose with bicycles. (Both, courtesy of Ben Blackburn.)

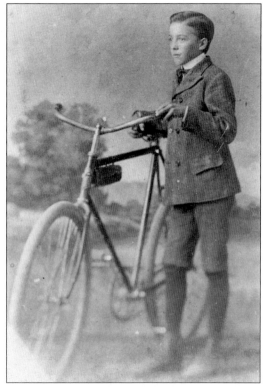

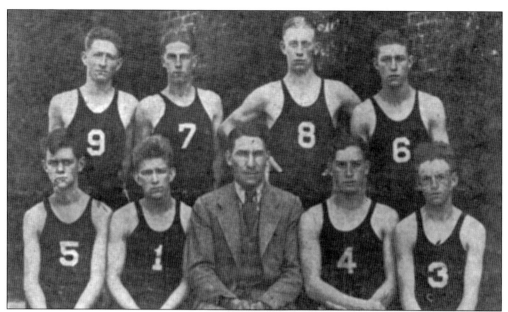

BASKETBALL. Like baseball, basketball was an early popular sport in Watauga County. This successful Cove Creek High School team, seen here around 1933, was the runner-up to a team from Candler, North Carolina, at a tournament in Mars Hill, North Carolina. Shown here are, from left to right, (first row) Stanley Harris, Joe Banner, coach Claude Pyatte, Olen Combs, and Hoy Isaacs; (second row) Vance Henson, Tom Lawrence, Fred Mast, and Jack Henson.

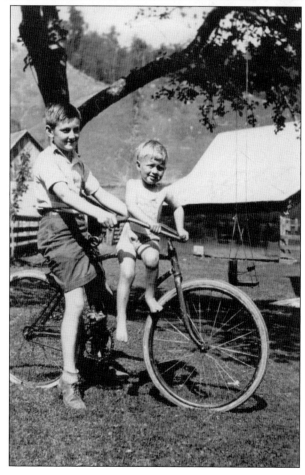

BOYS ON A BIKE. In this c. 1934 photograph are Gordon Spainhour Jr. (left) and his cousin Jimmy Mast of Cove Creek. In 1937, at age 16, Spainhour completed a 1,800-mile bike ride across North Carolina and collected signatures of mayors and other city officials, including Gov. Clyde Hoey. Sadly, Spainhour was killed a year later in a bicycle accident as a North Carolina State University freshman. (Courtesy of James B. Mast Jr.)

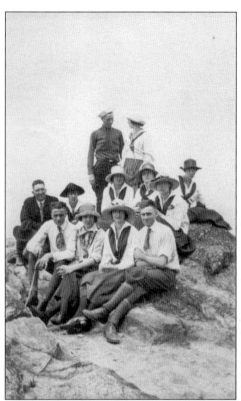

MOUNTAIN OUTING. This c. 1920 photograph demonstrates that the mountains and hiking trails of the High Country have been popular through the generations. Here, a group of students from Appalachian Training School in Boone, including James B. "Jim" Mast (first row, left), pose on a rocky summit. (Courtesy of James B. Mast Jr.)

BEAUTIFUL BABIES. This photograph shows a 1952 baby contest. The judges are David Barnard Dougherty (standing, far left) of Appalachian State Teachers College and former Boone mayor Watt Gragg (standing, far right). The contestants include Gerald Baird with his mother Louise (seated, second from left), and Jackie Henson with his mother Edith (seated, far right).

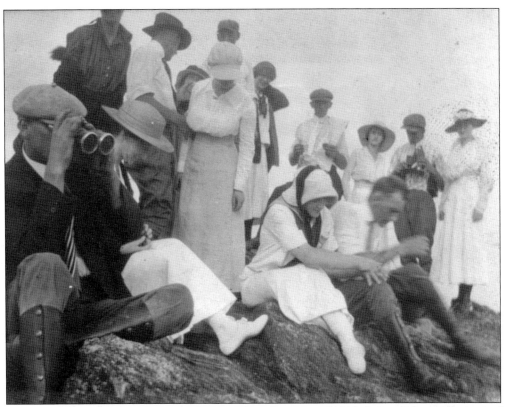

EXPLORING TATER HILL. These two photographs, taken around 1914, show a fashionable group of young explorers from the Cove Creek community taking in their natural surroundings on Tater Hill near Zionville. (Both, courtesy of James B. Mast Jr.)

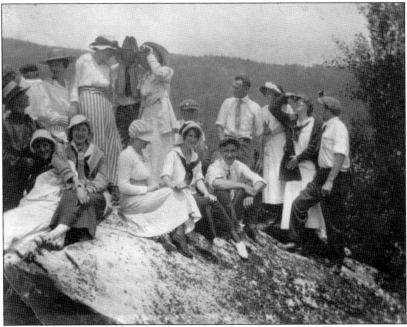

Cove Creek Sing-along? The dress of these merry young people from Cove Creek indicates how special outings were. Judging by the instruments in the photograph, this 1890s gathering must also have been a musical one. Pictured are, from left to right, (Shober ?) Rogers, Ella Sherwood, ? Clawson, Mattie (Glenn ?), Dave Swift, Hattie Jenkins, Bob Bingham, and Addie Mast. (Courtesy of James B. Mast Jr.)

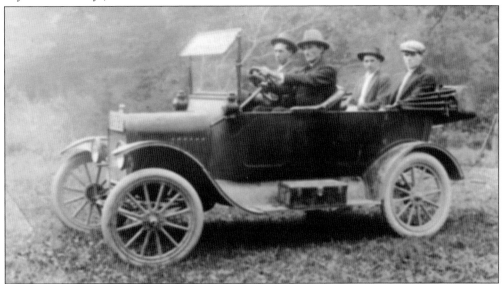

Vet on Wheels. One of the first automobile owners in Watauga County was the county's first veterinarian, Dr. George Hamilton Hayes (1868–1953). He is seen here, perhaps in 1916, in his car with unidentified passengers. He received his veterinary science diploma in 1907 and served farmers in Watauga, Ashe, Avery, Wilkes, and Johnson Counties, treating domestic animals.

74

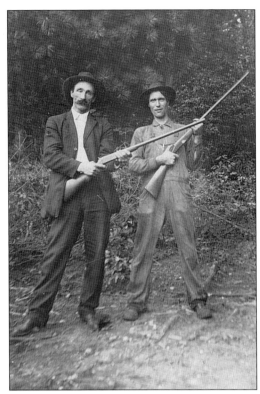

MEN AND GUNS. A necessary item in any mountain home was a firearm, and most early residents possessed a shotgun or rifle, used for hunting game for food as well as for protection against predators, human or otherwise. In the photograph at right, George Washington Greene (left), the maternal grandfather of renowned musician Doc Watson, and his brother-in-law Harvey Greene of Stony Fork Township carry their guns. Below, Frank Potter (left) and his brother-in-law Bob Clawson of Bald Mountain Township are seen with theirs. (Right, courtesy of Sandra Blankenship; below, courtesy of Ben Blackburn.)

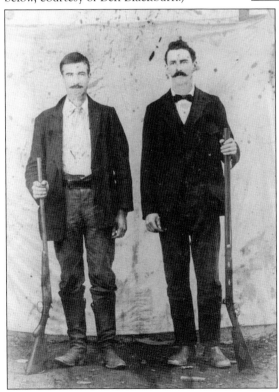

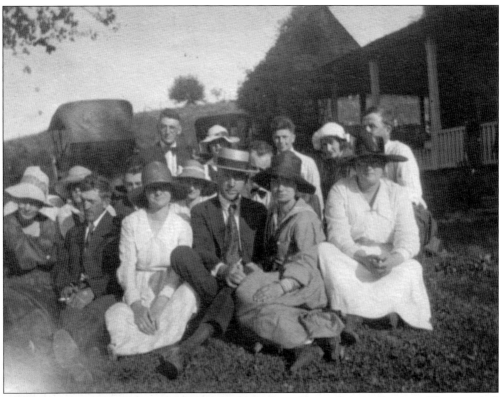

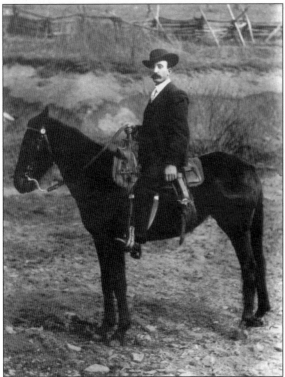

VALLE CRUCIS OUTING. This group of well-dressed young men and women enjoys a rest on the lawn of the Hard and Vickie Taylor home at Valle Crucis around 1910. Across the road from Mast General Store, this home's conical-roofed gazebo at porch's end is visible. The home is presently utilized as the restaurant Over Yonder. (Courtesy of James B. Mast Jr.)

RIDING IN STYLE. This dapper rider of an ebony steed is Jordan Luther "Jerd" Shull (1877–1953) of Laurel Creek. He is posing around 1900.

Four

OH, PLAY ME THAT MOUNTAIN MUSIC!

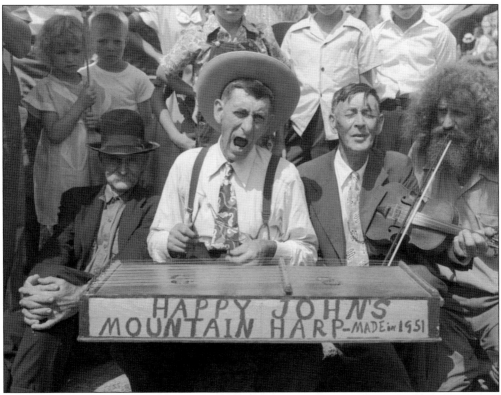

"HAPPY JOHN" COFFEY. Pictured in the 1950s, John Wesley "Happy John" Coffey (1877–1967) performs on Grandfather Mountain at the annual Singing on the Mountain. Coffey suffered a debilitating childhood burn, preventing him from playing a banjo or fiddle, so he invented his own instruments, including this "mountain harp," a combination autoharp and hammer dulcimer. (Courtesy of the North Carolina Collection, University of North Carolina Library at Chapel Hill.)

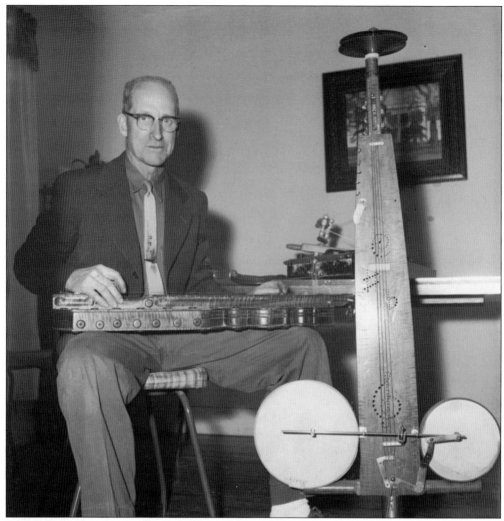

LUTHER CHARLES OLIVER SR. A resident of the Mabel community in western Watauga County, Oliver (1904–1987) was a 25-year employee of Appalachian State University in Boone, a skilled carpenter and craftsman, and an accomplished inventor. He is pictured here in 1963 with a few of the original and unique musical instruments he created, including the dulcimer-autoharp hybrid that he is playing. (Courtesy of University Archives, Appalachian State University.)

ARTHEL LANE WATSON. "Doc" Watson (1923–2012) was a Deep Gap native blinded before his first birthday. He began his musical career as a youngster, playing a $10 guitar ordered from Sears. Watson progressed to public performances on the streets of Boone, and eventually became a world-renowned, Grammy Award–winning artist known for his bluegrass, country, blues, folk, and gospel performances. (Courtesy of David Holt.)

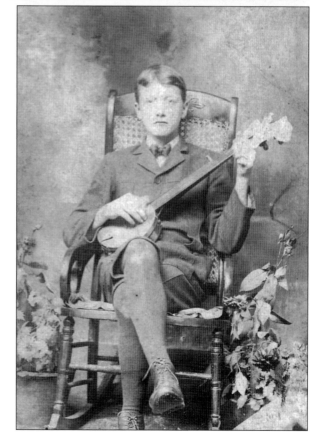

BANJO PICKER. Benjamin Isaacs, possibly of Cove Creek Township, seems quite relaxed and content in this studio portrait as he strums a tune on a down-sized banjo. (Courtesy of James B. Mast Jr.)

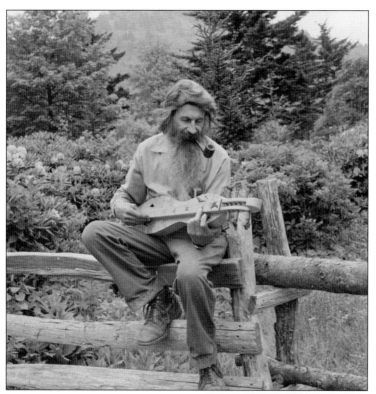

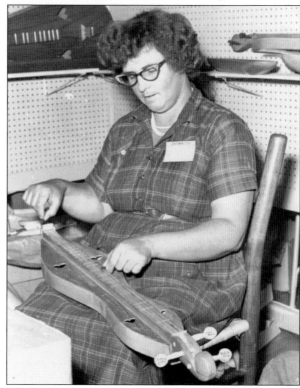

EDD AND NETTIE PRESNELL. Edd Presnell (1916–1994) and his wife, Nettie Hicks Presnell (1918–1997), were extraordinary craftspeople and traditional musicians. Edd learned how to make dulcimers from Nettie's father, Ben Hicks. The couple received the prestigious Brown-Hudson Folklore Award in 1974 for dulcimer-making and woodcarving. They were also the subjects of many articles. (Left, courtesy of the North Carolina Collection, University of North Carolina Library at Chapel Hill.)

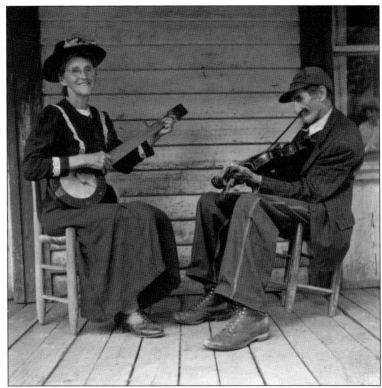

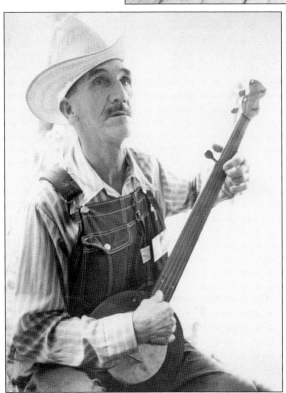

ROBY, BUNA, AND STANLEY HICKS.
Seen in the above photograph, taken
in 1939, Roby Hicks (1882–1957) and
Buna Presnell Hicks (1888–1984) of
Beech Creek were mountain tradition
keepers. Roby made tools, wagon
wheels, churns, barrels, furniture,
tubs, baskets, and banjos, and he
built log cabins. He carved wooden
ladles, spoons, and forks and took
them across Beech Mountain to sell.
He learned ballads from his mother,
Becky Harmon Hicks, and Buna
learned spiritual songs while attending
church on Beech Mountain, where her
father, Andrew J. Presnell, preached.
Buna was a talented entertainer who
played the fiddle and dulcimer, sang,
and danced. This heritage was passed
on to their descendants, including
son Stanley Hicks (1911–1989, left), a
well-known, award-winning craftsman
and player of traditional musical
instruments. (Above, courtesy of the
Warner family; left, courtesy of the
State Archives of North Carolina.)

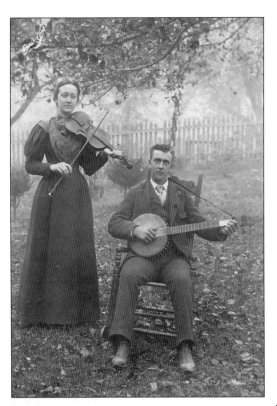

SIBLING DUET. Floy Farthing (1877–1962) and her brother, Roby Farthing (1879–1932), of the Timbered Ridge community in Beaver Dam Township, appear to be providing a melodious duet for their photographer. (Courtesy of Bob Barnhardt.)

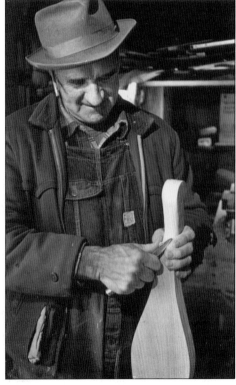

DULCIMER MAKING. Woodworker Iris Harmon (1911–1988) is seen here in 1975 in his shop in the Cool Springs community of Shawneehaw Township. His grandfather Eli Presnell reportedly handcrafted the first dulcimer in Watauga County after examining and making a tracing of one brought to the Beech Mountain area in 1885 by a "stranger from the west." (Courtesy of David Gaynes.)

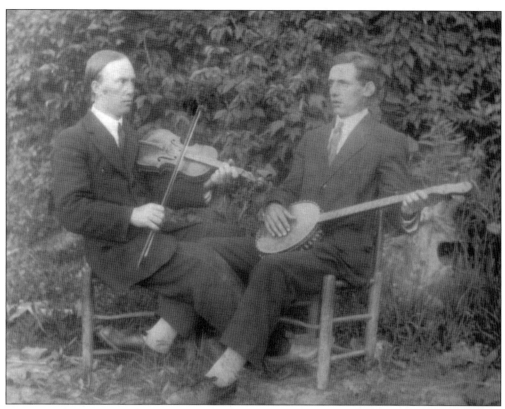

MUSICAL IMPOSTERS. In this photograph from around the 1910s, Ed Yates (1891–1959, left) and Jim Michael (1895–1968) from the Cool Springs community in Shawneehaw Township appear to be providing a lovely concert. Actually, neither could play an instrument.

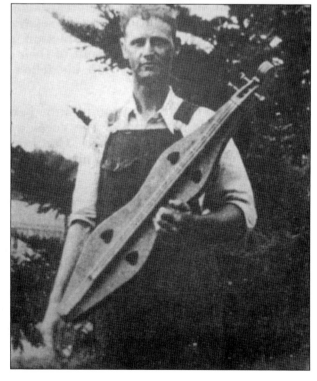

NATHAN TALBERT HICKS. Hicks (1896–1945), of Laurel Creek Township, lived near Beech Mountain and was a talented ballad singer and dulcimer maker. He is seen here around 1935 with one of his handcrafted instruments.

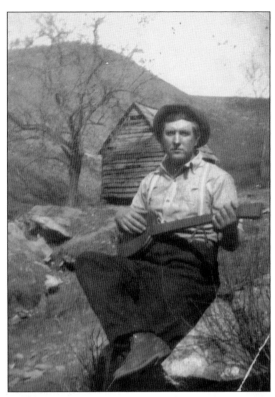

MOUNTAIN PICKERS. These instrumentalists from Laurel Creek Township are Thomas Graves "Tom" Glenn (1893–1966) and his wife, Lora Ann Tester Glenn (1896–1994). Although both could play traditional instruments, they more often sang, at home and in their church, Antioch Baptist, on Watauga River. Both, and especially Tom, were experts at old-time, shaped-note singing. (Both, courtesy of Tony Matheson.)

Five

MOUNTAIN FASHION

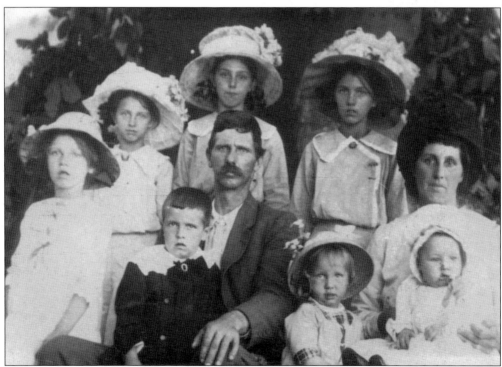

ANDY HICKS FAMILY. Bonnets abound in this c. 1910 photograph of the Andy and Susanna Presnell Hicks family, who lived in Laurel Creek Township near Beech Mountain. Pictured with the couple are the first seven of their sixteen children. The little ones in front are, from left to right, Lee, Sarah Ellen, and Windsor. The four girls standing are, from left to right, Linda, Lula, Viney, and Rena. (Courtesy of Margaret Trivette.)

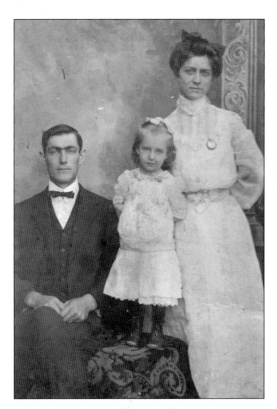

STUDIO PORTRAIT. The smartly dressed subjects of this c. 1904 photograph are James Walter "Watt" Henson (1879–1949); his wife, Maggie Horton Henson (1881–1971); and their eldest daughter, Inez (1902–1981). They were residents of Fletcher Branch in the Cove Creek community of Amantha.

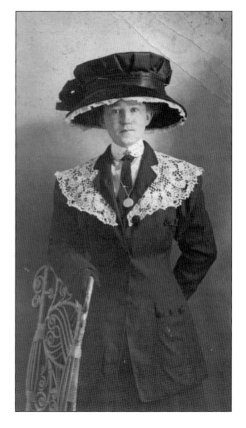

MARY LIZZIE TAYLOR. This fashionable young woman is Mary Lizzie Taylor (1897–1968) of Valle Crucis, a granddaughter of Henry Taylor, original proprietor of what became Mast General Store, and of former county sheriff David F. Baird. She was engaged to her cousin Thomas Sims Mast, who died during the 1918 worldwide Spanish influenza epidemic while serving with the US Medical Corps. (Courtesy of James B. Mast Jr.)

LORENZO DOW AND ANN DYER WARD. This classic-looking mountain couple is Lorenzo Dow Ward (1834–1918) and his wife, Ann Dyer Ward (1843–1925). Ward, a farmer and blacksmith, lived on Phillips Branch near Cove Creek. His home has been occupied by descendants up to the present day. Ward served in the county's Confederate Home Guard and was a deacon and faithful member of the old Antioch Baptist Church on Watauga River.

SAM AND BECKY HARMON HICKS. Posing here around 1912 are Sam Hicks (1848–1929) and Becky Harmon Hicks (1842–1919). Becky lost her left arm in a cane mill. She was the daughter of Council Harmon, a musically inclined storyteller, particularly of the "Jack Tales." These talents were passed on to many of her and Sam's descendants. Grandson Ben Hicks plays the fiddle in the wedding scene in 1974's *Where the Lilies Bloom*, filmed in and around Watauga County.

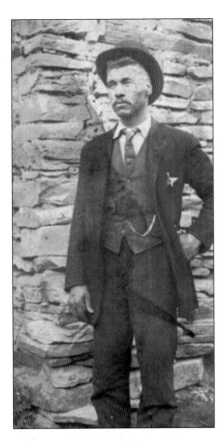

ELBERT PINKNEY WHITTINGTON. Pictured around 1912 and looking dapper in a derby hat, "Ebb" Whittington (1874–1946) was born to former slave Lucinda Whittington. His daughter Ruth was married to Rev. Ronda Horton, a much-loved pastor of the Boone Mennonite Brethren Church. Ebb is buried in Cove Creek Baptist Church Cemetery in what appears to be a once-segregated "colored" section.

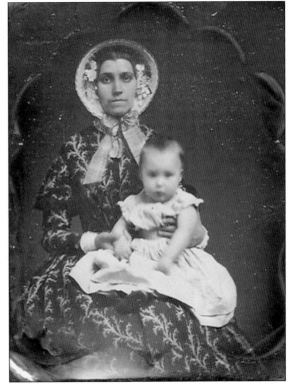

PRISCILLA MCGINNIS. Priscilla Walker McGinnis (c. 1812–1890), with a child on her lap (perhaps her eldest daughter, Martha) is the beautifully dressed and bonneted subject of this c. 1840s image. A native of Wilkes County, she moved to Valle Crucis with her husband, John, by 1860. Their son Isaac Jefferson McGinnis was an early Baptist minister in Watauga County.

MATCHING OUTFITS. Maximum utilization of yard goods often resulted in several members of a family donning similar articles of clothing. This is evident in the matching shirts and pants modeled around 1907 by brothers Jesse Ford (1889–1929, left) and Harvey Ford (1892–1945) of Blue Ridge Township.

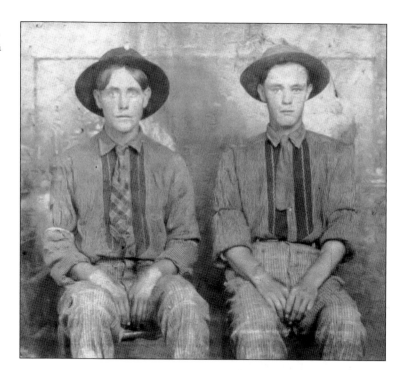

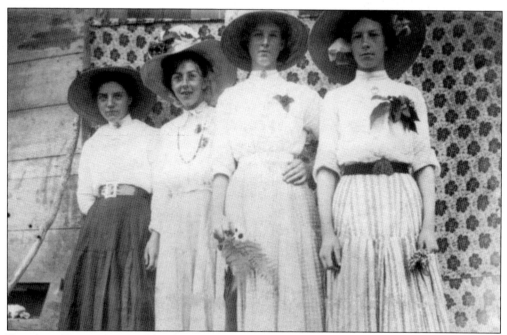

BELLES OF BEECH CREEK. The dressy ladies in this c. 1910s photograph are, from left to right, Matilda Presnell, Leona Presnell, Hattie Bell Presnell, and Bertha Guy of the Beech Creek community. (Courtesy of David Harmon.)

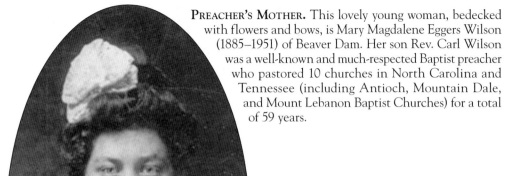

PREACHER'S MOTHER. This lovely young woman, bedecked with flowers and bows, is Mary Magdalene Eggers Wilson (1885–1951) of Beaver Dam. Her son Rev. Carl Wilson was a well-known and much-respected Baptist preacher who pastored 10 churches in North Carolina and Tennessee (including Antioch, Mountain Dale, and Mount Lebanon Baptist Churches) for a total of 59 years.

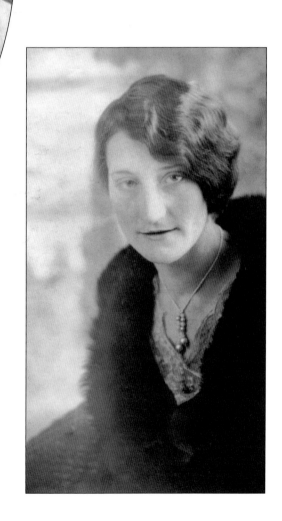

"THE WAVE." This stylish young woman wrapped in fur is future schoolteacher Amy Henson (1905–1980) from the Amantha community at Cove Creek. She is modeling the "finger wave" hairdo that became popular in the 1920s flapper era.

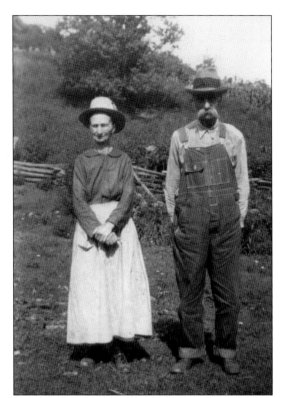

FARMING COUPLES. These photographs from around the 1930s offer typical portrayals of farming couples of the North Carolina mountains. Dressed in overalls and aprons, Ham and Emma Wilson Wallace (right) were farmers and residents of North Fork Township. Eli and America Banner Presnell (below) lived and farmed in the Beech Creek community.

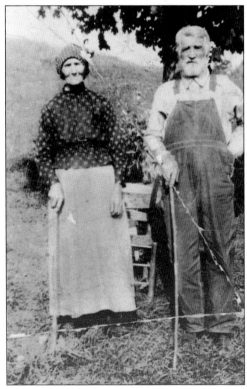

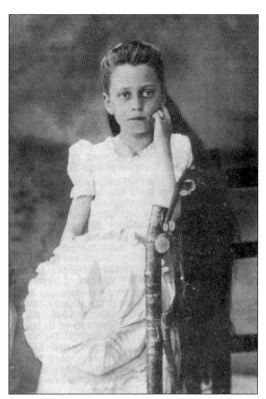

MOUNTAIN RAPUNZEL. This pensive lass with long tresses is Mary Lillington Hardin (1885–1911), granddaughter of Jacob Councill, who was killed in Stoneman's 1865 raid on Boone. In 1910, she married Edgar Shull, brother-in-law of D.D. Dougherty, a founder of present-day Appalachian State University. She died in 1911 at age 26 after delivering a stillborn child and is buried in Boone City Cemetery. (Courtesy of Grace Councill.)

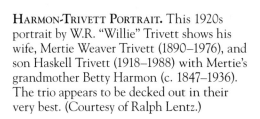

HARMON-TRIVETT PORTRAIT. This 1920s portrait by W.R. "Willie" Trivett shows his wife, Mertie Weaver Trivett (1890–1976), and son Haskell Trivett (1918–1988) with Mertie's grandmother Betty Harmon (c. 1847–1936). The trio appears to be decked out in their very best. (Courtesy of Ralph Lentz.)

Six

NATIVES AND
OTHER NOTABLES

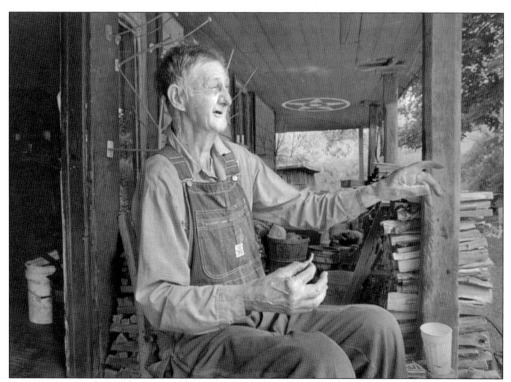

RAY HICKS. A storyteller best known for the "Jack Tales," Hicks (1922–2003) was a performer at the annual National Storytellers Festival in Jonesboro, Tennessee. Featured on PBS and in *National Geographic*, Hicks was deemed a national treasure by the Smithsonian Institution. He received the National Heritage Fellowship Award from the National Endowment of the Arts and a North Carolina Heritage Award from the North Carolina Arts Council. (Courtesy of David Holt.)

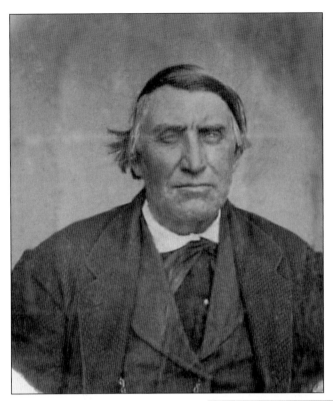

SHERIFF JACK HORTON. A farmer, merchant, and slave owner, Horton (1816–1884) was sheriff of Watauga County in 1852–1856 and 1866–1876. He built the county's third jail around 1865. In Boone, he resided near the courthouse and operated a tanyard and storehouse, where he sold whiskey and goods and kept a harness and saddlery shop. An avowed Unionist, Horton was partially compensated by the federal government for material losses suffered during Stoneman's 1865 raid on Boone.

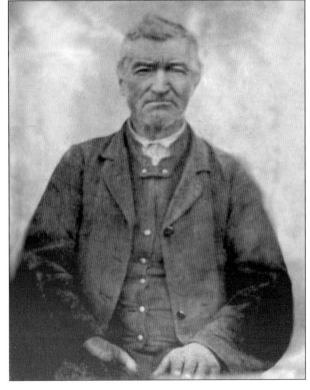

BENJAMIN COUNCILL SR. A wealthy farmer, slave owner, and justice of the peace, Ben Councill (1807–1877) lived on Brushy Fork and built a log storehouse, mill, and what is believed to be the first brick house in the county. While his brother gave land for the establishment of the town of Boone, Ben refused to supply land for a courthouse. In 1865, Union forces camped in his meadow, took his food and horses, and marched to Boone, where they killed his son Jacob.

ROMY STORY. In 1953, Appalachian State Teachers College dedicated the Romy Story Monument at College Field. No longer in existence, it was a tribute to the Blowing Rock native educated at Watauga Academy. The school's star baseball pitcher, Story (1882–1907) was subsequently captain of the University of North Carolina football and baseball teams. Popular and much loved, his untimely death from typhoid fever was widely reported by the press, which declared him "one of the greatest athletes in the south."

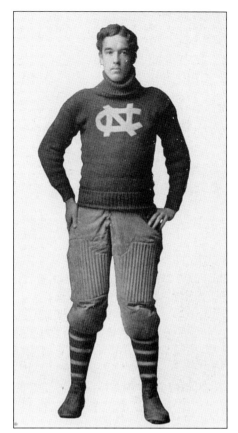

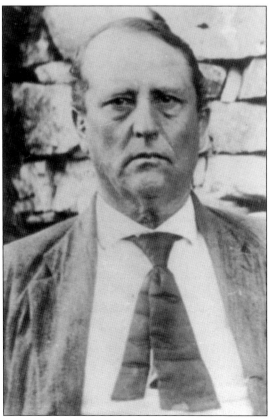

TARLTON PULASKI ADAMS. A Confederate veteran and 44-year board of education member, "Dock" Adams (1846–1922) helped establish Appalachian Training School and Watauga County Bank and served the Appalachian State Teachers College board until his death. Romulus Z. Linney said of Adams, "He could have been a member of Congress or a Judge . . . but . . . he would rather . . . sit on his . . . porch . . . [and] listen to the lowing of the cattle and the song of birds and have . . . peace and quiet and loving words."

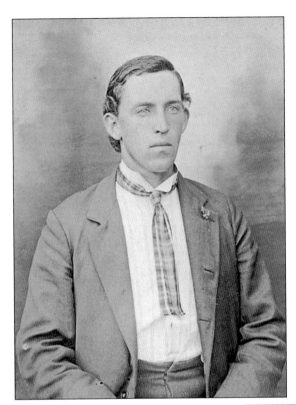

AMOS WELLINGTON HOWELL. One of the county's first law officers killed in the line of duty, "Wellie" Howell (1880–1902) was deputized to arrest Boone Potter of Pottertown, an isolated community with a reputation for violence. Potter shot Howell in a gunfight and escaped. Howell was also hit in the head with a rock thrown by Potter's cousin Clarence Potter, who surrendered. Despite medical attention, Howell died almost three weeks later.

MAJ. MYLES KEOGH. One of Watauga's more interesting "visitors," Keogh (1840–1876) participated in Gen. George Stoneman's 1865 raid on Boone. Keogh left Ireland and joined the Papal Guard in Rome. In 1862, he responded to a plea for soldiers to bolster the Union army during the Civil War. He fought at Gettysburg and participated in postwar campaigns alongside Gen. George Armstrong Custer. Both were killed at Little Big Horn.

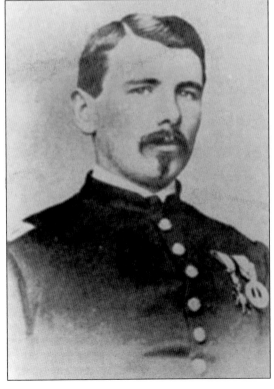

Dr. Jordan Bower Phillips.
A physician, merchant, and stock raiser, "J.B." Phillips (1841–1923) was a Confederate army sergeant and served in the North Carolina House of Representatives. He earned his medical license in 1885 and began practicing in Boone with his cousin Dr. Jefferson Councill. He made house calls on horseback and sometimes on foot, saddlebag on shoulder, to render aid to his patients. (Courtesy of Hilda Greer.)

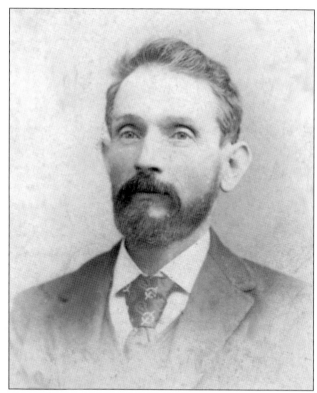

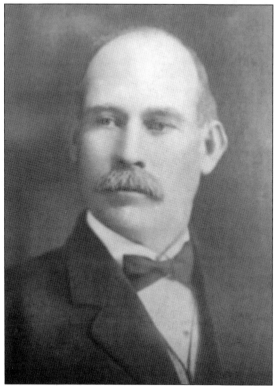

Williams Ballard Councill Jr.
"W.B." Councill Jr. (1858–1940) began his law career in Boone in 1881 and served in the North Carolina state legislature in 1896. His father-in-law, Thomas Jefferson Coffey, was a Boone merchant and hotelier. Councill moved to Hickory in 1899 and served as district superior court judge from 1900 to 1910. He was elected to the North Carolina Senate in 1912. This portrait once graced the Watauga County Courthouse.

HOWARD COTTRELL. Seen here around 1960, Cottrell (1907–1983) served 27 years (1944–1971) as manager of Appalachian State University's bookstore. He was mayor of Boone (1959–1961), a 22-year city councilman, and served two terms as a Watauga County commissioner. Cottrell owned and operated Cottrell Apartments, which provided housing for many university students and faculty. His former home is now the site of ASU's College of Education. (Courtesy of University Archives, Appalachian State University.)

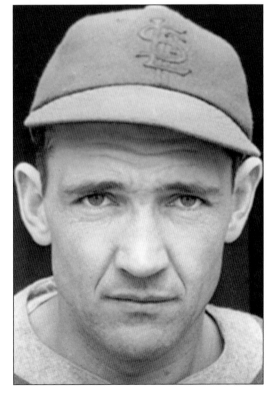

COAKER TRIPLETT. Appalachian Training School's baseball team captain and football halfback, Triplett (1911–1992) played professional baseball with the Chicago Cubs (1938–1941), the St. Louis Cardinals (1941–1943), the Philadelphia Phillies (1943–1945), and the Buffalo Bisons (1946–1950). Returning home, he coached Boone's baseball team in 1953. He was inducted into the Appalachian State University Hall of Fame, the Watauga County Sports Hall of Fame, and the International League Hall of Fame.

EDMUND SPENCER BLACKBURN. Admitted to the North Carolina bar in 1890, Blackburn (1868–1912) practiced law in Jefferson, served as North Carolina Senate clerk (1894–1895), and was elected to the state house (1896 and 1897). A two-term US congressman (1901–1903 and 1905–1907), he was a friend of Pres. Theodore Roosevelt. Following service in the US House of Representatives, he resumed practicing law in Greensboro. (Courtesy of Ben Blackburn.)

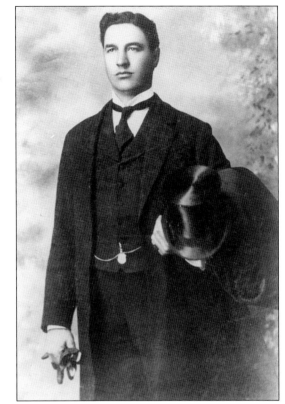

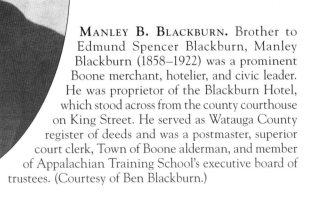

MANLEY B. BLACKBURN. Brother to Edmund Spencer Blackburn, Manley Blackburn (1858–1922) was a prominent Boone merchant, hotelier, and civic leader. He was proprietor of the Blackburn Hotel, which stood across from the county courthouse on King Street. He served as Watauga County register of deeds and was a postmaster, superior court clerk, Town of Boone alderman, and member of Appalachian Training School's executive board of trustees. (Courtesy of Ben Blackburn.)

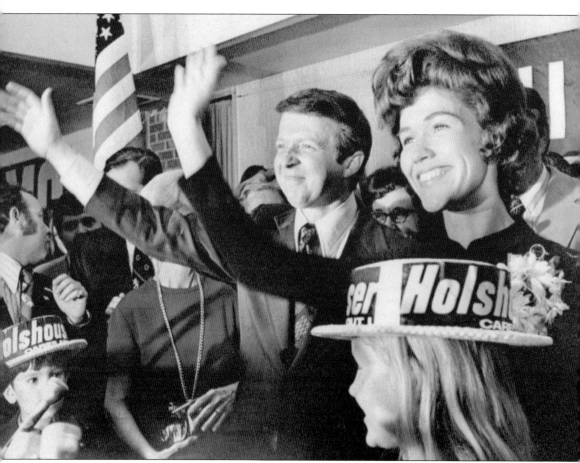

James Eubert Holshouser Jr. Holshouser (1934–2013) is the only Watauga County native to serve as governor of North Carolina (1973–1977). He was the state's first Republican governor since 1896 and the last not eligible for a second four-year term. Elected at age 38, Holshouser was the youngest governor since the 19th century. He is the namesake of the portion of US Highway 321 between Boone and Blowing Rock. A graduate of the University of North Carolina School of Law and a former North Carolina general assemblyman, he consolidated the UNC system under a board of governors, improved community college funding, and established health clinics in rural communities. Pictured with him is his wife, Pat Hollingsworth Holshouser (1939–2006). The first lady of North Carolina at age 33, she oversaw the 1975 restoration of the Governor's Mansion in Raleigh. A native of Asheville and a graduate of Appalachian State University, Caldwell Community College, and the University of North Carolina at Chapel Hill, she was the daughter of Dr. Leon H. Hollingsworth, who once served as pastor of First Baptist Church in Boone. (Courtesy of the *News & Observer.*)

SARAH SHULL AND DAVID COLBERT McCANLES. In 1859, Sheriff David Colbert "Colb" McCanles (1829–1861) left Watauga, relocating his family to Nebraska and supposedly absconding with county funds. Sarah Shull (1833–1932), for whose family Shulls Mills is named, lived with them, presumably as McCanles's mistress. McCanles (below) leased part of his ranch as Rock Creek Station, a stopover for stagecoaches, Pony Express riders, and Oregon Trail travelers. In 1861, James Butler "Bill" Hickok, a stage driver mauled by a bear and needing light duties while recuperating, arrived. Animosity grew between McCanles and Hickok, some asserting that both men had an interest in Shull (right). Amid an argument between McCanles and the station keeper, Hickok shot and killed McCanles. Shull left Nebraska, married, ventured to several states, and divorced. Returning to Shulls Mills by 1900, she was a private woman reluctant to speak of her past, and she lived with family until her death.

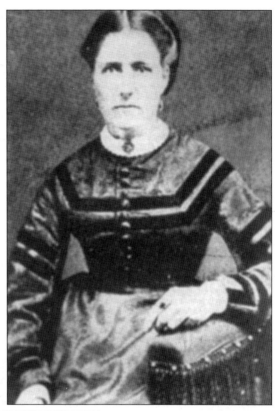

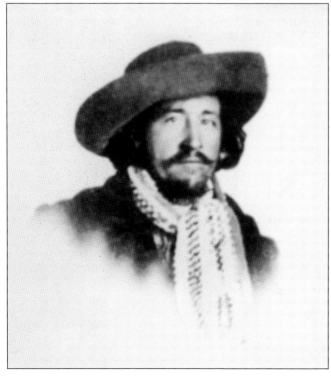

CALVIN JONES COTTRELL. Calvin Cottrell (1843–1923), pictured with his wife, Malissa Norris Cottrell, was a Confederate sergeant in Company I, 58th Regiment, North Carolina Infantry and lost an eye in the Battle of Resaca, Georgia, in 1864. Back home in Watauga County, Cottrell served as a justice of the peace, presiding over hearings and officiating weddings. His son David Jones Cottrell and grandson Howard Jones Cottrell served as Boone mayors. (Courtesy of Jack Henson.)

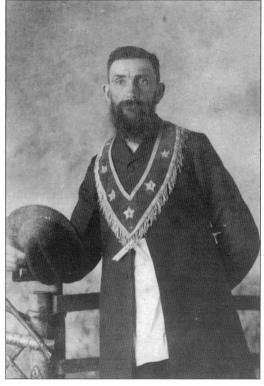

JAMES WASHINGTON HORTON. Jim Horton (1846–1924) of Vanderpool was a Confederate veteran and prisoner of war, progressive farmer, civic leader, and education proponent. He became a Mason in 1875 and was a Snow Lodge charter member in 1878. Between 1916 and 1922, he served as district deputy grand master for the 35th Masonic District, comprised of Watauga and Avery Counties. This June 1894 portrait shows him in his Masonic collar and apron.

BANNER BROTHERS. Originally called Banner's Elk and part of Watauga County, the town of Banner Elk is now part of Avery County, which was created in part from Watauga in 1911. In 1840, Yadkin County merchant Martin Luther Banner (1808–1895) first saw Elk Creek Valley surrounded by Beech, Sugar, Hanging Rock, and Grandfather Mountains. Moving his family there, Martin (right) built a log cabin on the banks of Elk River near present-day Lees-McRae College and was the first permanent white settler there. Five more Banner brothers followed—Lewis, John, Anthony, Edwin, and Matthew. Lewis (1805–1883, below), a staunch Unionist but also a slave owner, offered his home during the Civil War as a refuge for Union sympathizers trying to get through Federal lines in east Tennessee and Kentucky and guided Union men through the mountains to avoid the Confederate Home Guard.

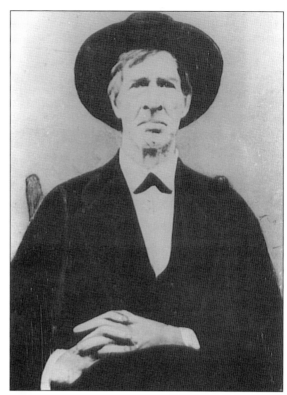

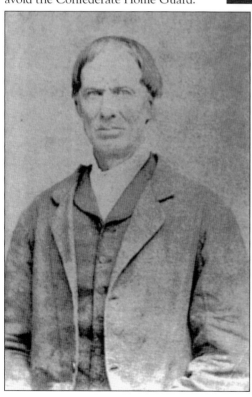

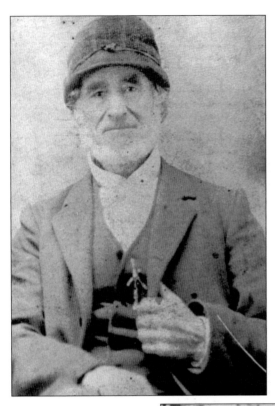

ASA REESE. Born in a log house on Cove Creek, Reese (1820–1898) rose above his humble circumstances, obtained an education, and temporarily ventured across the Ohio and Mississippi Rivers on a sojourn to Platte Purchase, Missouri. The area was replete with Indians, frontiersmen, riverboat pilots, trappers, traders, wildcats, and rattlesnakes. He detailed these life experiences in his journals, providing a rare window into 19th-century life.

RITA SHERIDAN. Arriving with a circus that performed in Blowing Rock and Boone, Sheridan (c. 1877–1908) soon became ill and died at the Critcher Hotel three months later. Following her death, Rev. William Savage, concerned that some citizens questioned Sheridan's Christianity, wrote to the *Watauga Democrat* that she had expressed "her belief in her Savior." He hoped to satisfy any who doubted "show people" and urged them to become more broad-minded. Sheridan's now-broken tombstone marks her grave in the Boone City Cemetery.

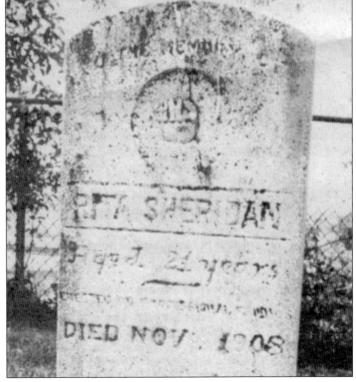

Seven

MOTHER NATURE

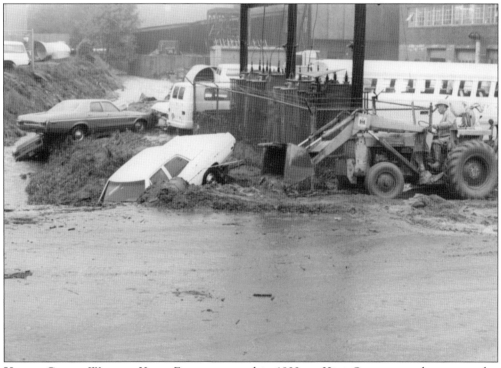

KRAUT CREEK. Watauga Kraut Factory opened in 1922 on King Street near the present-day Agricultural Extension Office. Excess liquid from cooked cabbage was piped into Boone Creek, earning its nickname, "Kraut Creek." Mostly hidden underneath streets and sidewalks, the creek is prone to flooding. This 1973 photograph, taken near the Appalachian State University steam plant, shows the aftermath of the creek's flooding. (Courtesy of University Archives, Appalachian State University.)

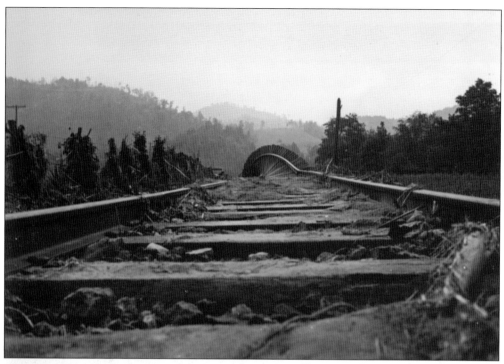

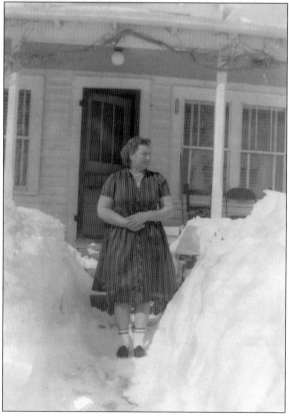

DAMAGED TRACK. The flood of 1940 ended the railroad in Watauga County. This photograph shows a portion of the track uprooted, twisted, and covered with debris. According to one account, "The damage to the track looked like somebody put a picket fence in the middle of the field. The ties were sticking out of the ground with the dual gauge track still on the ties."

HEAVY SNOW. The snowfall of 1960 is one of the county's best-remembered disasters. That February, heavy snow fell every Wednesday, totaling 30 inches on the ground. March brought 51 additional inches. Drifts covered houses, roads were impassable, and school was cancelled for weeks. The American Red Cross and the National Guard provided assistance, and helicopters dropped food to some residents. Here, Rose Edna Harmon stands in her yard in the Cool Springs community near Matney.

Eight

EVERYONE LOVES
A PARADE!

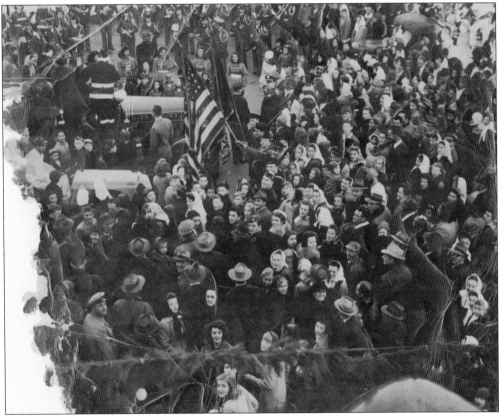

CHRISTMAS PARADE, 1949. This crowd may have been one of the largest turnouts ever for the Boone Christmas Parade. Spectators gathered to see a color guard, a marching band, majorettes, and, of course, Santa Claus, who can be seen standing on a vehicle in the upper left, with his back to the photographer. (Courtesy of the Historic Boone Collection, Watauga County Public Library, and NC Digital Heritage.)

CENTENNIAL PARADE. The Hortons, an early and influential family in Watauga County, descended from Nathan Horton, a Revolutionary War veteran who moved from New Jersey to North Carolina around 1785. Many family members were civic leaders, including Henry Walter Horton Sr. (1873–1968), pictured here on horseback at Watauga County's 1949 centennial celebration. He is wearing his great-grandfather Nathan's military uniform. (Courtesy of the Historic Boone Collection, Watauga County Library, and NC Digital Heritage.)

ASTC HOMECOMING PARADE. These high-stepping majorettes lead the Appalachian State Teachers College band eastward on King Street in 1956. Looking west, the former 1875 Watauga County Courthouse is visible to the far left, just below the dome of the 1904 courthouse. Near the center of the photograph is the rock building that once housed the Linney law office. (Courtesy of University Archives, Appalachian State University.)

NEITHER RAIN NOR FOG. Despite inclement weather seen in this c. 1968 photograph, the Watauga High School Pioneer mascot, cheerleaders, and band make their way east on King Street. This photograph reveals some of the businesses in existence at the time, including, from left to right, Linzy's Hobbycrafts Records & Gifts, Thrif-Tee Discount, Carolina Pharmacy, Sears, College Hall, Stallings Jewelry, Varsity Menswear, Coe Insurance, Appalachian Theatre, and the Gateway Restaurant (at the Coca-Cola sign). Across the street are the Daniel Boone Hotel, Crown, and Tastee-Freez. (Courtesy of University Archives, Appalachian State University.)

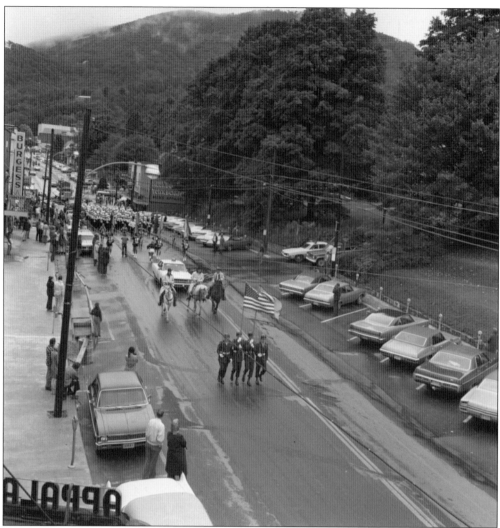

ASU HOMECOMING PARADE. This photograph, taken from atop the Appalachian Theatre, captures a color guard, men on horseback, and a squad car leading a flag corps, majorettes, band, and floats eastward on King Street in 1972. At top left is the Watauga County Courthouse. Businesses include Burgess Furniture, Flowers Photo Shop, NCNB, Hunt's Department Store, and a men's apparel store, none of which remain today. The tree-shaded lawn of the Jones House is at center. At right is the old Daniel Boone Hotel's terraced lawn. (Courtesy of University Archives, Appalachian State University.)

PARADE DOWN KING STREET. These two photographs from the late 1950s or early 1960s capture parade participants on a drizzly day in front of the former Daniel Boone Hotel, heading west on King Street. In the photograph at right, a car donning a *Horn in the West* poster carries members of the outdoor drama's cast, including Glenn Causey as Daniel Boone (a role he played for 41 years) and Bill Ross as British loyalist Dr. Geoffrey Stuart (a role he originated). Below, bystanders are reminded of the prominent roles covered wagons and oxen played in early transportation.

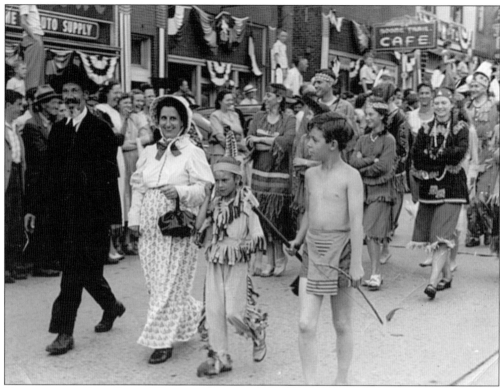

ECHOES OF THE BLUE RIDGE. Watauga County's 1949 centennial celebration included an original dramatic production, *Echoes of the Blue Ridge*. The cast participated in the centennial parade down King Street in Boone. Above, Dave and Texie Hodges lead the actors, with Larry Klutz (front right) as a young brave. The two "Indian maidens" at far right in the next row are Frances "Sissie" Rush (left) and Florence Lawrence (right). Boone Trail Café is in the background. Below, Klutz is seen again, followed by Rush and Lawrence. The ladies behind them are Pat Ellis (second from right) and Cleo Bolick (right). Glenn Hodges is believed to be at far right with arms crossed. The Watauga County Bank, decorated with bunting, is in the background, at the corner of King and Depot Streets. (Both photographs by Palmer Blair, courtesy of Sarah Spencer via Larry Klutz.)

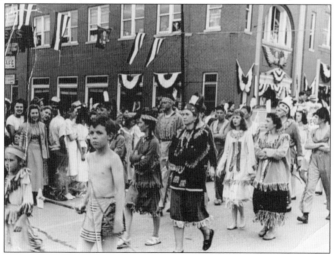

Nine

AROUND THE APPALACHIAN STATE UNIVERSITY CAMPUS

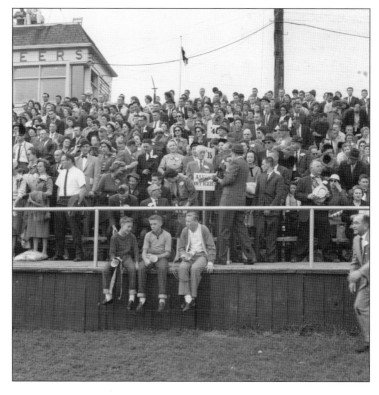

HOMECOMING, 1960. Spectators on the "home" side of College Field enjoy this football game, including members of the classes of 1935 and 1940. Also in attendance is university bookstore manager Howard Cottrell, standing in the front at far right, with hat in hand. (Courtesy of University Archives, Appalachian State University.)

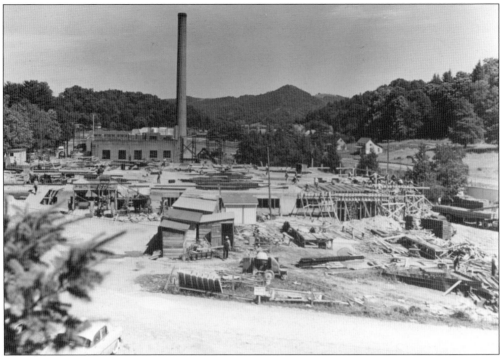

Broome-Kirk and Varsity Gymnasiums. Though later eclipsed by today's George M. Holmes Convocation Center, Appalachian State University's Broome-Kirk Gym (seen above under construction around 1954) and Varsity Gym (seen below under construction in 1967) played a vital part in the life of the university as well as the greater community. Varsity Gym served as the venue for many Watauga High School graduations, as well as sporting events, concerts, and the once-popular Watauga County Spring Festival. Broome-Kirk Gym has since been demolished and is now the site of the Alice G. Roess Dining Hall. Above, on the right looking east, note the pastoral and agrarian characteristics of the undeveloped Rivers Street, now the site of Katherine Harper Hall–W. Kerr Scott Hall and John E. Thomas Hall. (Both, courtesy of University Archives, Appalachian State University.)

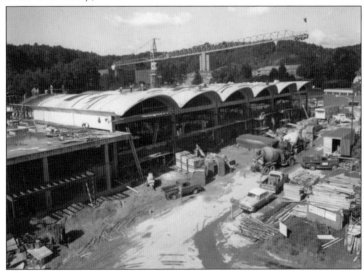

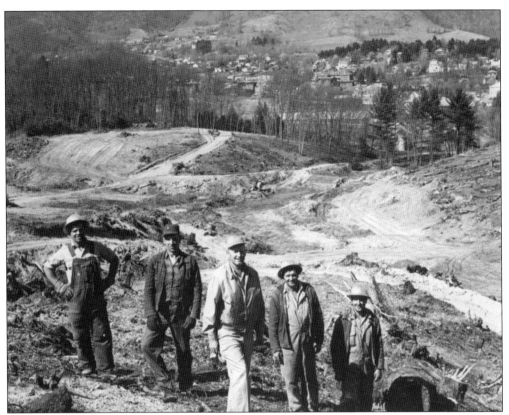

CONRAD STADIUM. As with Varsity Gymnasium, Conrad Stadium has been an important facility not only for Appalachian State University but for the greater Watauga County community, playing host to football games of the university and, formerly, the high school. Pictured above is the beginning of the stadium's construction in 1961, with the town of Boone as the backdrop. Shown below is a billboard advertising the coming expansion of the stadium in 1975. (Both, courtesy of University Archives, Appalachian State University.)

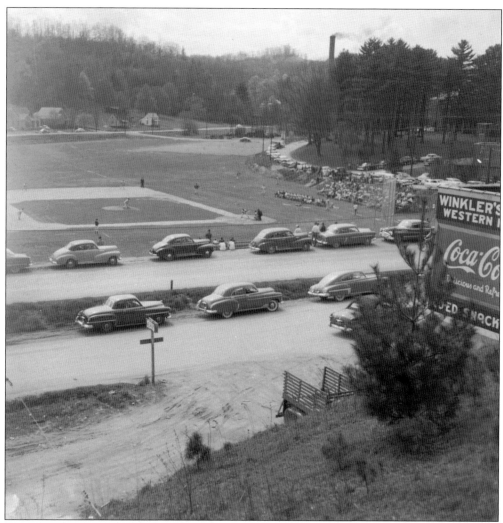

BASEBALL FIELD. As Appalachian Training School expanded into Appalachian State Teachers College, so did the school's baseball program. This 1954 photograph shows the ASTC baseball field at the corner of Rivers Street and Blowing Rock Road in Boone. It is seen here much as it appeared until its relocation many decades later. This former baseball field, which was dedicated as Red Lackey Field in 1987, is now occupied by Durham Park on the campus of what is now Appalachian State University. Note in the background the ASTC steam plant's smokestack (right), as well as a less-developed Rivers Street, with a few of the faculty houses visible at far left. (Courtesy of University Archives, Appalachian State University.)

COLLEGE FIELD. Prior to the construction of Conrad Stadium, College Field was home to Appalachian State's Mountaineer football team and was an especially important focal point during the school's annual homecoming games. This photograph, looking west toward the Rich Mountain range in the background, shows halftime activities during the 1955 homecoming game. (Courtesy of University Archives, Appalachian State University.)

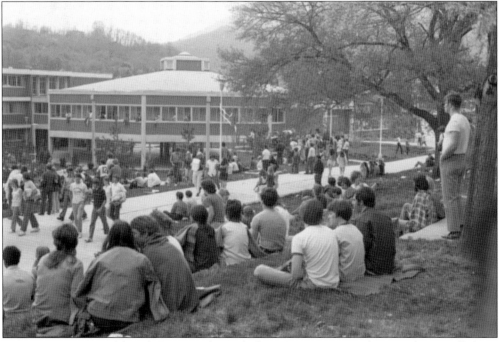

VIETNAM BOYCOTT. Although Boone and Appalachian State University have not historically been the scenes of large-scale protests, this 1972 photograph shows university students behind Edwin Duncan Hall, boycotting classes to express their disapproval of the escalation of the Vietnam War. (Courtesy of University Archives, Appalachian State University.)

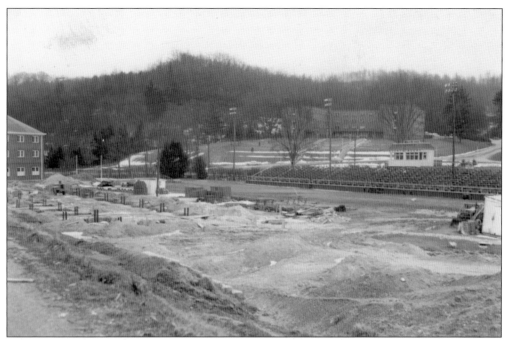

COLLEGE FIELD DEMOLITION. The once-popular Appalachian State football field was demolished in 1962 (above), after the opening of Conrad Stadium. It is now the site of Edwin Duncan Hall, the well-known octagon of which can be seen under construction (below) around 1964. (Both, courtesy of University Archives, Appalachian State University.)

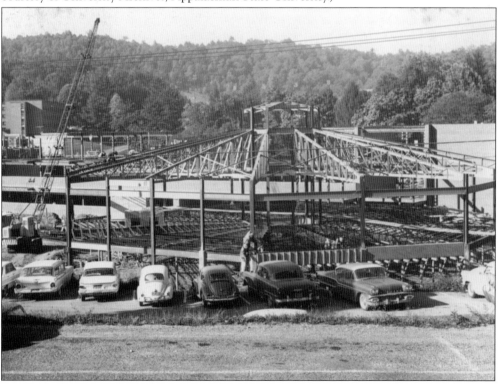

Ten

LOCAL LANDMARKS

STONEMAN'S RAID. The only Civil War skirmish in Boone took place during the March 1865 invasion by Union troops, part of Gen. George Stoneman's raid on northwestern North Carolina. Pictured here, Appalachian State University history professor Dr. Ina Van Noppen (1906–1980) authored *Stoneman's Last Raid*, one of the earliest works to document the raid. The book earned her the Thomas Wolfe Memorial Award. (Courtesy of University Archives, Appalachian State University.)

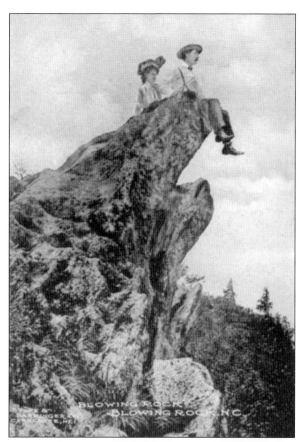

THE BLOWING ROCK. Although not officially a tourist attraction until 1933, the Blowing Rock, a cliff 4,000 feet above sea level and overhanging the Johns River Gorge 3,000 feet below, drew sightseers much earlier. The postcard at left, likely dating from the turn of the 20th century, portrays a couple atop the rock. Numerous cars in the photograph below attest to the site's popularity. (Left, courtesy of the Bobby Brendell Postcard Collection, Watauga County Historical Society, and the Digital Watauga Project; below, courtesy of the North Carolina Collection, University of North Carolina Library at Chapel Hill.)

GRANDFATHER MOUNTAIN. These two postcards portray earlier times at Grandfather Mountain, the popular tourist destination. Above, the winding road up the mountain is shown before it was paved. Shown below are the busy parking lot and picnic area, complete with an outdoor grill, opposite the stairs leading up to the mountain's famous Mile High Swinging Bridge. (Both, courtesy of the Bobby Brendell Postcard Collection, Watauga County Historical Society, and the Digital Watauga Project.)

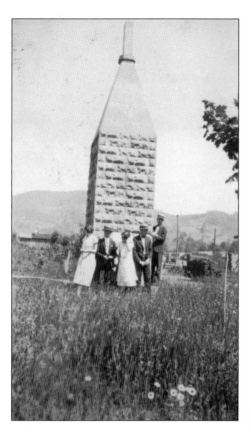

DANIEL BOONE CABIN MARKER. The original Daniel Boone Cabin Marker, shown at left in 1925, was constructed in 1912 by Boone's first mayor, William Lewis Bryan, to commemorate the site of a hunting cabin in which the famous frontiersman is said to have stayed during his forays into what is now Watauga County. This marker was torn down and reconstructed 50 yards west in 1968 (below) to allow for the widening of Rivers Street. The second marker was demolished in 1994 to accommodate new campus construction. Local dentist and historian Dr. Gene Reese, founder of Historic Boone, assumed guardianship of the memorial plaques and capstone from the original and subsequent cabin markers until they could be incorporated into the third, current marker, built in Rivers Park in 2005. (Both, courtesy of University Archives, Appalachian State University.)

NASA Windmill. Touted as "the world's largest windmill," this structure was erected by NASA in 1978–1979 atop Howard's Knob to generate electricity. Although an object of interest and the impetus behind a souvenir market, the project was dismantled in 1983 due to mechanical difficulties and funding cuts. Some living nearby complained of television reception interference and the "swooshing" of its 100-foot blades. In the photograph below, one of the blades is transported up to Howard's Knob. (Right, courtesy of David Harmon; below, courtesy of University Archives, Appalachian State University.)

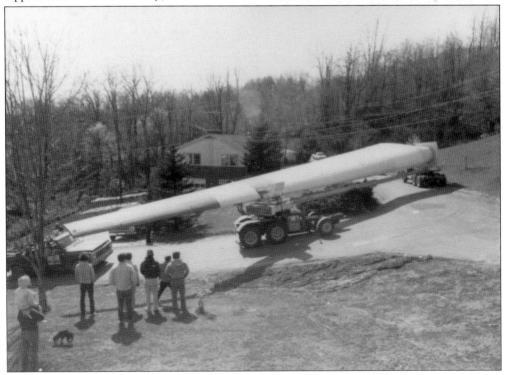

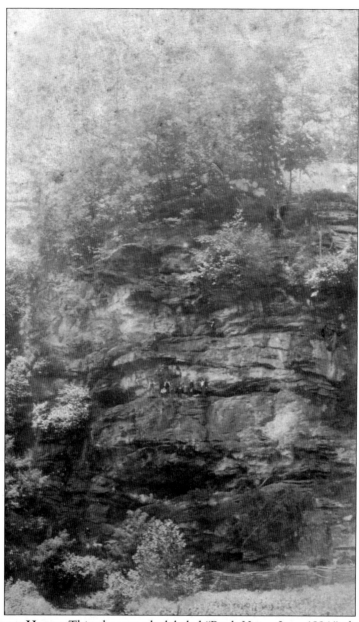

HARMON'S ROCK HOUSE. This photograph, labeled "Rock House June 1894," almost certainly depicts Harmon's Rock House, off of US Highway 321 in Sugar Grove, with Cove Creek running west toward its base and then directly south. Tradition states that early settler Cutliff Harman arrived in the area in the 1790s and, having no immediate home for his family, took shelter in this rock house. Also referred to as Herman's Cliff, it was believed to have originally been known as Shupe's Rock House, because a Shupe family had lived here. It has been claimed that the first white child born in present-day Watauga County was born here. Nearby Phillips Branch was formerly known as Rock House Branch, due to its proximity to the rock house. A skeleton of an unidentified person was discovered in one of its caves in 1845. Note the people standing on a ledge about halfway up the cliffs, an indication that this natural landmark may once have been a popular local attraction. (Courtesy of James B. Mast Jr.)

DANIEL BOONE TRAIL MARKERS. In 1913, the Daughters of the American Revolution, to commemorate Daniel Boone's trail through present-day Watauga County, placed six iron plaques on large boulders at Cook's Gap, the original Three Forks Baptist Church, the courthouse in Boone, Hodges Gap, Graveyard (or Straddle) Gap, and Zionville. Only two remain intact. The one at the courthouse is no longer attached to its original boulder, but to a rock wall in an adjacent courtyard. The Zionville marker (above) is located on Emory Greer Road and is the only marker in the county in its original form and location. The photograph below, probably taken between 1913 and 1930, shows, from left to right, Robert Horton, Mott J. Robertson, and Don Horton. They are posing with one of the original markers—probably at Graveyard Gap, on Linville Creek Road. (Below, courtesy of James B. Mast Jr.)

BOONE TRAIL HIGHWAY AND MEMORIAL ASSOCIATION MARKERS. Inspired by the Daniel Boone Trail markers installed by the Daughters of the American Revolution, "Hamp" Rich of Mocksville endeavored to build the Boone Trail Highway and erect markers as memorials to Daniel Boone. Between 1927 and 1928, three markers were placed in Watauga County. The first, presented to Appalachian State Normal School and the Town of Boone, stood until it was displaced by street improvements around 1957. The Blowing Rock marker (left), located near the Martin House on Main Street, in front of the Blowing Rock History Museum, originally stood two miles north. It was gifted to the Town of Blowing Rock, restored, and moved to its current location in 2006. The Sugar Grove marker (below), adjacent to the Western Watauga Community Center on Old US Highway 421, is the only one in Watauga County in its original form and location.

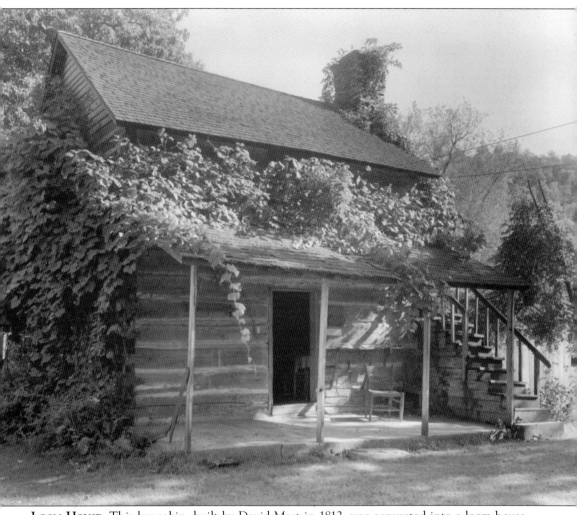

LOOM HOUSE. This log cabin, built by David Mast in 1812, was converted into a loom house for sisters Josie, Leona, and Mattie Mast. They were expert weavers of fringes, linens, and other pieces. Their output was significant enough to support a mail-order business. Each had her own loom; Josie's had belonged to David's wife. Part of the Mast Farm Inn, the cabin, seen here in 1938, now provides guest accommodations. (Courtesy of the Library of Congress.)

DISCOVER THOUSANDS OF LOCAL HISTORY BOOKS FEATURING MILLIONS OF VINTAGE IMAGES

Arcadia Publishing, the leading local history publisher in the United States, is committed to making history accessible and meaningful through publishing books that celebrate and preserve the heritage of America's people and places.

Find more books like this at
www.arcadiapublishing.com

Search for your hometown history, your old stomping grounds, and even your favorite sports team.

Consistent with our mission to preserve history on a local level, this book was printed in South Carolina on American-made paper and manufactured entirely in the United States. Products carrying the accredited Forest Stewardship Council (FSC) label are printed on 100 percent FSC-certified paper.

MADE IN THE

USA